# BOTANICAL DRAWING IN COLOR

A Basic Guide to
Mastering Realistic Form and
Naturalistic Color

WENDY HOLLENDER

*Wendy Hollender*

WATSON-GUPTILL PUBLICATIONS

New York

Published in the United States by Watson-Guptill Publications, an imprint of the
Crown Publishing Group, a division of Random House, Inc., New York.

www.crownpublishing.com

www.watsonguptill.com

WATSON-GUPTILL is a registered trademark and the WG and Horse designs
are trademarks of Random House, Inc.

Library of Congress Cataloging-in-Publication Data

Hollender, Wendy.

 Botanical drawing in color : a basic guide to mastering realistic

form and naturalistic color / by Wendy Hollender. -- 1st ed.

 p. cm.

 Includes index.

 ISBN 978-0-8230-0706-6

 1. Botanical illustration--Technique. 2. Color drawing--Technique. I.

Title.

 QK98.24.H647 2010              743´.7--dc22

 2009023921

Printed in China

Designed by Kara Plikaitis

10 9 8 7 6 5 4 3 2 1

First Edition

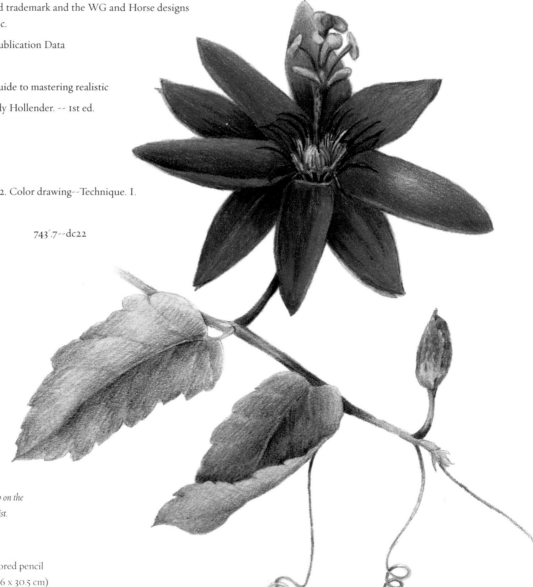

Front Cover Image:

*Shell Ginger (Alpinia speciosa),*
2008, colored pencil on
watercolor paper,
16 x 12 inches (40.6 x 30.5 cm)
*I drew this shell ginger while teaching a workshop on the
Big Island, Hawaii. It was just too unusual to resist.*

Back Cover Image:

*Helleborus x Hybridus (Hellebore),* 2005, colored pencil
on watercolor paper, 16 x 12 inches (40.6 x 30.5 cm)
*This drawing was created as part of a group of hellebores prints.
A well-known nursery called Sunshine Farm and Gardens developed
this hybrid for its Sunshine Selections series.*

This book is dedicated to my mom, Selma Hollender, who instilled in me a love of plants, flowers, and floral designs throughout her lifetime.

The exploration of botanical art and illustration has had a tremendous impact on my life. It has guided me in a direction of continuous discovery for the past twelve years. Thanking everyone who has helped make this possible would take up a chapter alone. The various gardens and staff that I have worked with, the instructors from all over the world, botanists, horticulturists, students, friends, and family are too numerous to mention by name, but please know that I am thankful and appreciative beyond words. I must start by thanking the New York Botanical Garden for having such an extensive certificate program in botanical art and illustration, staffed with talented and giving professionals, and for asking me specifically to teach classes in colored pencil. This gave me the opportunity to focus on a medium that I had previously used only as a convenience and that subsequently impacted my technique and love of drawing in color. I fondly mention the Riverside Park Fund, the Nantucket Conservation Foundation, and the Morven Museum and Garden for believing in my work early on. The Brooklyn Botanic Garden has given me numerous opportunities, including being a member of their florilegium, teaching there, and using their extensive collections. The ASA Wright Nature Preserve and the National Tropical Botanical Garden have been wonderful environments in which to work and hold workshops. Individuals who helped me specifically with this book deserve mention: Pat Jonas, for encouraging me to write this book; Julie Houston, for reading my initial manuscript; Candace Raney, my editor, for believing in this book right from the start and allowing me the opportunity to do it my way; Alison Hagge, for diligently editing and encouraging; Kara Plikaitis, for creating a stunning design; Susan Pell, for checking over the botany entries; and my enthusiastic students, for working hard and taking delight in the pursuit of botanical drawing. I have met many botanical artists through the American Society of Botanical Artists who have become good friends and colleagues, willing to share trade secrets without hesitation. I would also like to thank my friends Maggie and Connie, for promoting my work any chance they get; my dad, for being proud; my sisters, Jane and Beth, for standing by my side; and my brother, Herb, for his sense of humor. And lastly my two children, Abby and Jesse, for giving me the time and space to draw when they were young, happily drawing beside me, and as they became adults, for sharing my passion for plants and agriculture.

LEFT: *Passion Flower (Passiflora grandiflora) (detail)*, 2007, colored pencil on watercolor paper, 11 x 7 inches (27.9 x 17.8 cm). *The passion flower is unusual and beautiful, attracting numerous insects and people alike. It enticed me to try and capture its beauty in a drawing.*

ABOVE: *Tropical Flowers (detail)*, 2006, colored pencil on watercolor paper, 8 x 12 (20.3 x 30.5). *Tropical flowers, such as the plumeria (Frangipani) shown here, are terrific inspirations for color.*

# CONTENTS

*Calabash (Crescentia cujete)*, 2006,
colored pencil on watercolor paper,
16 x 12 inches (40.6 x 30.5 cm)

 **Note**: This icon is used
throughout the book before
an exercise that will require
you to do something other
than just read the text.

*The leaves of grandiflora magnolia are excellent for drawing, as they
are thick enough to retain their shape for many months.*

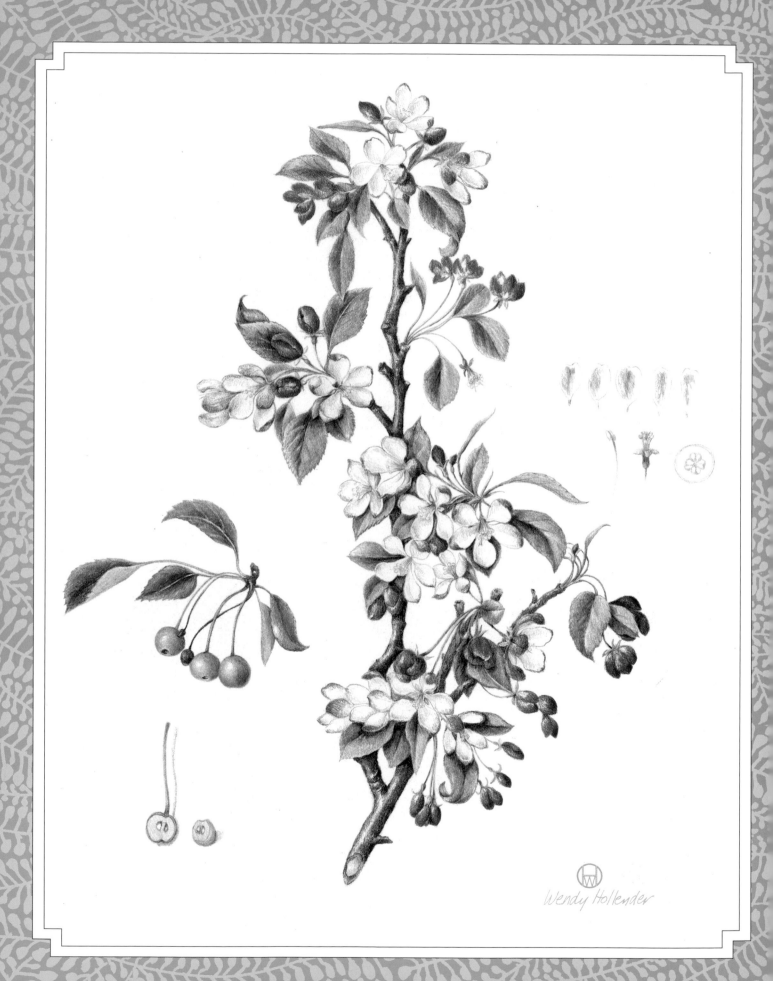

Wendy Hollender

# INTRODUCTION

D rawing is something I love to do, but it wasn't always that way. When I started to draw as a college student in art school, I felt overwhelmed. Creating the illusion of three dimensions on a two-dimensional piece of paper was complicated. A model that moved, a bird that flew away, a change in the natural light—these things made it even more challenging. It was only when I started to study the techniques of botanical illustration that I found a way to unlock the secrets of drawing—a way that had, until then, eluded me.

*Crabapple blossoms (Malus floribunda), 2005, colored pencil on watercolor paper, 16 x 12 inches (40.6 x 30.5 cm)*
*Riverside Park in New York City was my neighborhood park for thirty years. Every year I anxiously awaited the blossoming of the crabapple trees, which look and smell beautiful. Eventually I felt confident enough to draw a flowering branch for a calendar for the Riverside Park Fund.*

Plants and flowers are great subject matter. They don't run away, and they smell good! Observing nature's quiet beauty, structure, and color is a wonderful way to learn to draw and to experience nature at the same time. Plants can be used to learn drawing in a systematic way, which avoids the confusion I had experienced in life drawing class. For one thing, it is simple to take apart a flower and discover its internal structure firsthand. Try that one in a life drawing class!

I've always loved botanical illustrations. Long before I knew what they were called, I would stare at these exquisite flower "portraits" and wonder, *How did the artist do that?! How does that flower look so real, so vibrant, so three-dimensional.* At the same time, the flowers were so colorful, so detailed. Some even had water drops.

I first became professionally interested in botanical illustration through my work as a textile designer. In the 1970s I was fortunate to work with my childhood idol, artist turned textile designer Vera Neumann. Vera went by her first name as a designer, and her business was hugely successful in many areas, including fashion (she was most famous for her silk scarves), home decorating, and accessories. One late spring afternoon, I remember seeing a freshly cut, flowering dogwood branch on the table in Vera's art studio and right next to it a splashy watercolor interpretation of the flowering branch that she had painted that morning for a pillowcase design. With that dogwood, I was seeing firsthand Vera's ability to work directly from nature, which had been the basis of her famous television commercials in the late 1960s and a source of inspiration to me growing up. The commercials had shown Vera in her beautiful garden, painting a bold floral painting that was instantly turned into a bedding design that you could buy at Bloomingdale's and bring a little bit of Vera's garden into your own home.

I was in awe of Vera's ability to take a passion and turn it into something beautiful and practical. I shared her appreciation of the sun shining, the plants blooming, the birds chirping, and the bees buzzing . . . the intoxicating scents and the gentle breeze. I wondered what it must feel like to be a flower, flourishing in that environment. I wanted to be out there, too, in the garden as much as possible. I thought that being able to draw and paint the flower might be a way to experience that world, and if other humans would enjoy my pictures, that would be a plus. Vera's style was a very loose, painterly approach. She was a master at that, able to get the essence of the flower immediately. It looked easy, but it wasn't, and my early attempts lacked the strength of Vera's paintings.

In the 1980s I worked with other successful designers—for example, Laura Ashley and Ralph Lauren—who took a more traditional approach to design than Vera did. At that time, these designers were capitalizing on the renewed interest in realistic florals based on old documents. This is when I started studying botanical illustrations closely, for reference in creating realistic floral designs. I could copy an old document or even a photograph, but whenever I tried to use a live

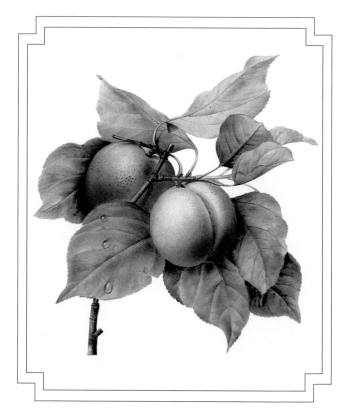

Pierre-Joseph Redouté, *Apricots*, circa 1827, watercolor on vellum, 9¹⁄₄ x 8 inches (23.5 x 20.3 cm), courtesy of Arader Galleries, New York. *These two botanical illustrations are the work of Pierre-Joseph Redouté, probably the most famous botanical artist of all time. His images have been reproduced over and over again, and I closely study his work to learn from his technique.*

flower as a model, I was frustrated with the results. I wanted to do what Vera had done—work outside in my own sunny garden all day and come up with beautiful floral paintings that represented the plants and flowers growing there, but in my own style. I wanted to work from live plants and create paintings that were different than splashy florals, loosely rendered in watercolor. I wanted to work in a spontaneous way as Vera had done but at the same time convey the realism exhibited in the old botanical documents.

I got out my watercolors and started to paint flowers. I kept a journal of the watercolor sketches of wildflowers I would make on walks in the country. I have these journals to

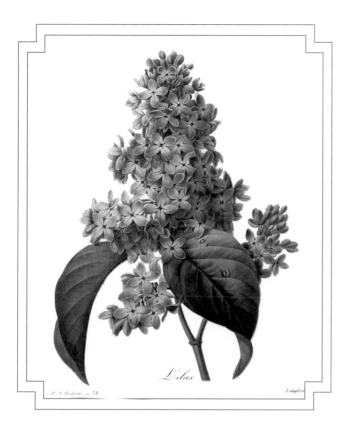

Pierre-Joseph Redouté, *Lilac*, from *Chois des Plus Belles Fleurs*, 1827–1833, hand-colored stipple engraving, 12³⁄4 x 9¹⁄2 inches (32.4 x 24 cm), courtesy of Arader Galleries, New York.
*Redouté was able to show the detail in every individual flower while also showing the whole group of flowers. His use of light source is well worth studying.*

this day, but try as I did, they were not "botanical" enough. I had captured pretty colors, and clearly rendered identifiable flowers, but they lacked the depth, detail, realism, and inner strength that convey an artist's clear vision.

I went back and noticed that the old botanical illustrations all had similar characteristics, regardless of the artist. Each artist's work had its own personality, and yet there was a tradition, a series of techniques, that they all seemed to follow. *They all must have gone to the same school*, I thought, and if so, I wanted to go there, too. Since many of these early botanicals originated in Europe, I assumed I would have to cross the Atlantic Ocean to learn these techniques. How surprised

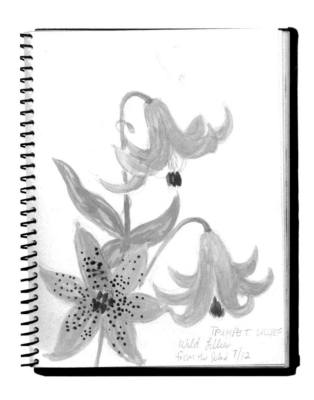

TRUMPET LILLIES
Wild Lillies
from the Island 7/12

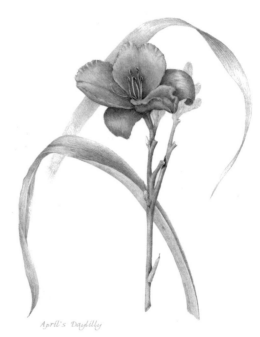

April's Daylilly

I was to find a program for studying botanical illustration practically in my own backyard—in New York City at the New York Botanical Garden!

I signed up in 1998 and quickly learned that the discipline of botanical illustration encompassed a series of techniques that could be practiced over and over again until the artist understood how to use these techniques to create a detailed botanical portrait. The secrets of botanical illustration were at last revealed to me, but as fate would have it, they came at exactly the time when another revelation would change my life entirely.

Toward the end of my first year of studying botanical drawing, I read about the world-renowned botanical artist Margaret Stones, who began to concentrate on botanical drawing while confined in bed by a long illness. She drew the flowers that were placed beside her.

Ironically, the very next week I was diagnosed with breast cancer. While undergoing extensive surgeries and chemotherapy, I remembered what I had read about Margaret Stones. When I was jolted wide awake in the middle of

the night, instead of focusing on my fears about cancer I would go to the dining room table and quietly start to draw the floral bouquets that friends and family had sent. I used the techniques my instructors had taught me. The intense concentration removed me from the panic I felt. Soon I would relax, and after two or so hours of work, I could go back to sleep.

In the months of treatment that followed, I would bring my drawing supplies and a flower to the hospital, and, as the nurses were hooking me up for the day's chemotherapy, I would focus on my drawing. My family looked on in disbelief that I could remain so calm, but it was clear to everyone who came into the room that this was my way of turning a traumatic time into one of rebirth and renewal.

While my hair was falling out and my ability to reproduce was prematurely ending, I started taking plant morphology at the New York Botanical Garden. We dissected plants and their reproductive parts and used the microscope to reveal form and structure that could not be seen with the naked eye. This unique combination of art and science put my work on

a whole new level of skill and understanding. My instructor's enthusiasm for his subject was infectious, and I bought my own microscope to use at home. It has been ten years since my experience with cancer and since the purchase of a microscope, and not a day goes by when I am not in awe of nature's wondrous forms and designs—as well as its power to distract and to heal the spirit.

I consider being introduced to the techniques of botany and botanical drawing at the same time that I was diagnosed with cancer to be a gift in my life. And now, after many years of studying, practicing, and teaching these techniques, this book comes out of my desire to share my joy in drawing plants and the technical knowledge I have learned. The skills I use in botanical illustration and share in this book I call "slow drawing." Step by step, I will reveal the secrets of drawing plants, at a relaxed pace that will give you the opportunity to absorb the skills through your fingertips and develop the confidence to draw what you see and know.

*Wendy Hollender*

## — A NOTE ON THE — STRUCTURE OF THIS BOOK

My approach is always to describe form first, color second. Once we have the form down, then I will show you how to use color theory to mix accurate colors. Color theory will also facilitate your ability to make pleasing color compositions. I introduce the use of color before color theory because I want you to enjoy and get used to adding color to a toned form. Once you have practiced and are enthusiastic about your progress (as I know you will be) we will go into a more in-depth study of color theory. The same goes for perspective. I want you to feel comfortable with the process of drawing before I introduce the complex and difficult subject of perspective. Having mastered some early basic exercises, you will be able to approach perspective with less trepidation.

 **Note**: This icon is used throughout the book before an exercise that will require you to do something other than just read the text.

This book is filled with exercises. Please do every one—even if you think you already understand the concept. Practicing the early exercises is like warming up for an athlete—it is useful, regardless of your level of experience, and will only help your performance and drawings later on. Plus, as you will see, it is quite gratifying!

One final note, do not strive to copy my illustrations, but rather learn my techniques and use them to create a realistic version of the plant you are portraying in your own style. You won't need to copy your plant exactly as it appears before you. This is not a crime scene! I will explain how to make decisions about what to ignore and what to include in your drawing. The ultimate goal is for you to feel that you are the one in charge, the CEO making decisions that only you can make so that in the end your drawings are exciting, informative, and unique to your point of view.

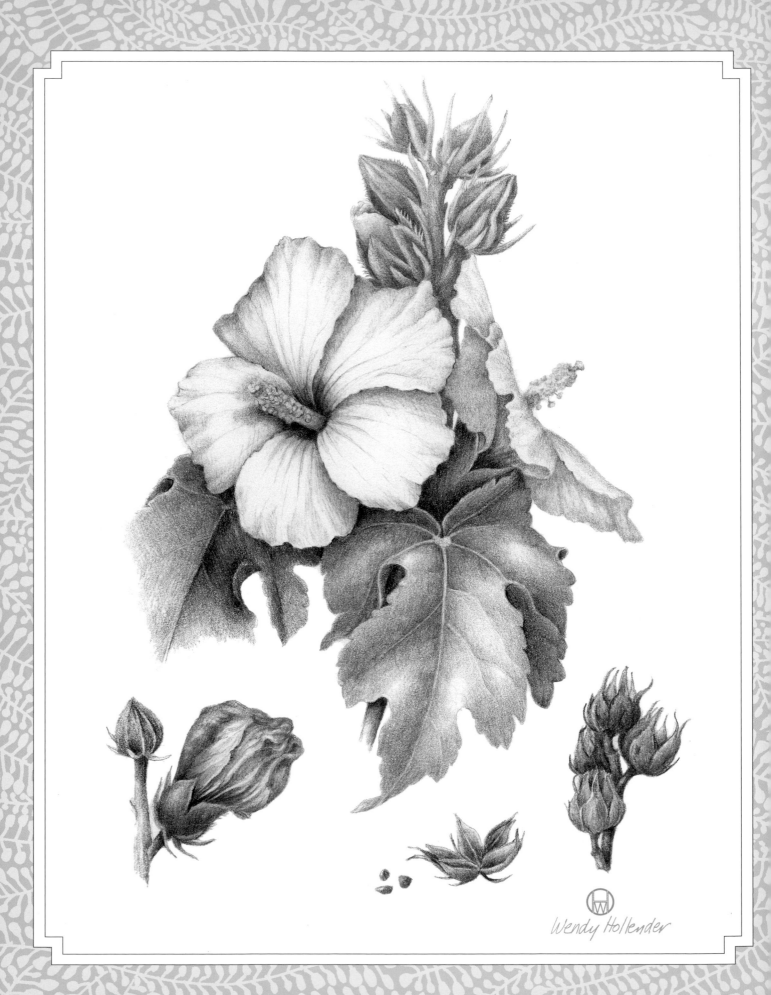

Wendy Hollender

# TAKING
# AN OVERVIEW

*Hibiscus (Hibiscus brackenridgei), 2008,
colored pencil on watercolor paper,
11 x 8½ inches (27.9 x 21.6 cm)
This drawing, of a hibiscus from Hawaii, is
part of an exhibition on endangered plants
called* Losing Paradise *that has traveled
to various botanical gardens and museums
in the United States. The hibiscus is a
well-known flower. Once you have studied
botanical drawing, you will realize how
many variations of this one flower there are.*

As you will soon discover in this book, no technique is too simple to describe. I am even going to show you how to sharpen your pencil! Here's why: When I was studying botanical illustration, I took a beginning plant morphology (botany) class. The instructor was throwing around all kinds of Latin names and complex terminology about plants. At the same time, he kept talking about flowers as if we knew what they were. Of course, I knew what a flower was, but did I really know what it meant in botany terms? I felt silly, but I raised my hand and in front of a room full of adults I asked my question: "What is a flower?"

This unleashed a detailed description from our instructor of what a flower actually is. It was fascinating. And guess what? No one else in the class had had any idea what a flower was, either! But then we knew, and from there we could go on to understand and learn the more complex terminology. (Just in case you were wondering, a flower is the reproductive structure of a tree or other plant, consisting of at least one pistil and/or stamen and often including petals and sepals.)

Discussing what seems obvious and elementary—but actually isn't—is what makes my style of teaching successful. So, yes, I will show you what a sharp pencil looks like and how to measure a flower and what exactly a "range of values" is. I will also show you how to slow down, observe closely, learn step by step, and then gently begin to take pencil to paper in a methodical but relaxed pace. This approach makes it possible for anyone to learn the techniques of botanical drawing. This is valuable for the beginner and the experienced artist alike.

Botanical illustration is as close to drawing as it is to painting. A keen ability to see and draw detail is as important as an ability to mix paint and paint with a paintbrush. In the beginning, the ability to draw accurately is actually more important than an understanding of painting techniques. Many people assume that botanical illustration can be learned from studying botanical painting techniques; however, I believe it is crucial to learn to draw first before trying to paint botanical subjects, as botanical illustration requires a precisely drawn subject.

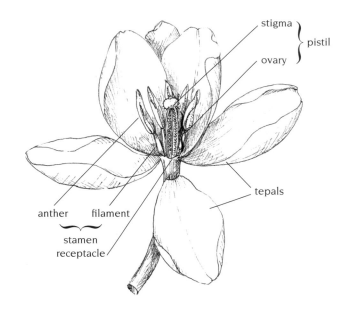

The pistil includes the three-lobed stigma (above) and ovary (below). The stamen includes the anther (above) and filament (below). The reproductive parts of a tulip are protected by three outer sepals and three inner petals that look similar. Collectively they are known as tepals.

These are the main challenges that I will be addressing in this book:

VALUE: The first challenge is to gain an understanding of value, or tone, and how it helps create the illusion of three dimensions on a two-dimensional surface. This will require practice of toning techniques, allowing you to gradually build layers of various values. These techniques work best with a sharp pencil.

LIGHT SOURCE: Another challenge is to master the use of a single, primary light source. Eventually an artist learns to imagine this light source in his or her head when it is not visible. This is contrary to everything I learned as an art student. No longer do I draw what I see. Instead, I now draw what I know and see. And I will help you do the same.

PERSPECTIVE: A third, crucial challenge is to learn how to use perspective to create depth on a two-dimensional surface. When I started drawing, I understood a little about perspective as it relates to horizon lines, vanishing points in the landscapes, buildings, and so forth, but I didn't know that drawing an organic form such as a plant also requires the mastery of perspective.

PLANT MORPHOLOGY: The final key challenge is to understand plant structure. This knowledge is the foundation of botanical illustration. In this book, you will gain an understanding of botany, plants, and nature firsthand. It will make your drawings more meaningful and accurate.

These basic drawing skills are beneficial, even if your ultimate goal is not to become a botanical illustrator. Through botanical drawing, you will learn skills that can be applied to all forms of drawing. And there's a bonus: You will also learn about color. I can't think of a better subject to learn from.

Nature uses colors in both subtle and intense beautiful combinations. You will learn to use colored pencil in a detailed, realistic fashion. In the process, you will be rewarded

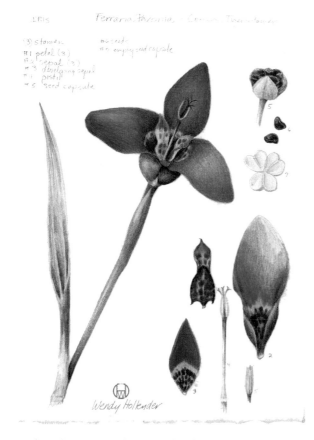

*Tiger Flower (Ferraria pavonia), 2007, colored pencil on watercolor paper, 11 x 7 inches (27.9 x 17.8 cm). This magnificent tiger flower was in bloom at the Wilson Botanical Garden in Costa Rica. I had never seen anything quite like it, so I studied and drew it immediately.*

with an experience unlike any other—for if you slow down and practice these techniques with me, you will experience an up-close-and-personal relationship with the cycle of life, exploring plants and flowers almost the way an insect does.

Of course you will work inside, setting up a workspace in your home, but try, whenever possible, to work outdoors. As soon as I started studying botanical drawing, I began drawing botanicals on location whenever I was in a beautiful place. I know every park in New York City—and which of them offer the best tables and chairs to work. Because I live in the urban setting of Manhattan, my idea of a vacation is usually getting away to the country somewhere and often to a tropical setting. The inspiration plants provide for me, a city dweller, is varied and unusual. I feel like a kid in a candy store. From

the start of my career as a botanical illustrator, I always knew I just had to work in color, and while my family members frolicked in the water or relaxed with a book, I could be found on the nearest lounge chair, drawing a flower. My colored pencils were all I had when traveling, so I started to develop a technique to capture the magnificent colors with only colored pencils. I would draw, take a break for a swim, and draw some more. I had found paradise. My desire to go to these exotic locations and work was more compelling than having a vacation. It gave new meaning to the term "busman's holiday."

It was during my travels, as I was experiencing the pleasure of drawing on location, that I realized I needed to turn this obsession into a career. Nowadays I go to Trinidad, Hawaii, and Nantucket, to name a few places, and I go there for work (if you can call drawing "work"). I create my own illustrations, often commissioned by local organizations, from plants growing there, and I bring students with me for workshops.

Even when I teach at home in New York City at one of the local botanical gardens, I look for ad hoc outdoor classrooms when weather permits. I think the drawings and certainly my experience while working are better for it. It is easier to observe the pollinators (which I no longer refer to as "annoying bugs") while working outdoors. The sounds of the birds and bees, the feel of the breeze, and the warmth of the sun add to the experience. I am happy from start to finish.

Through botanical drawing, you will learn, as so many of my students do, that it is possible and quite wonderful to relax and meditate through drawing. Come, give it a try!

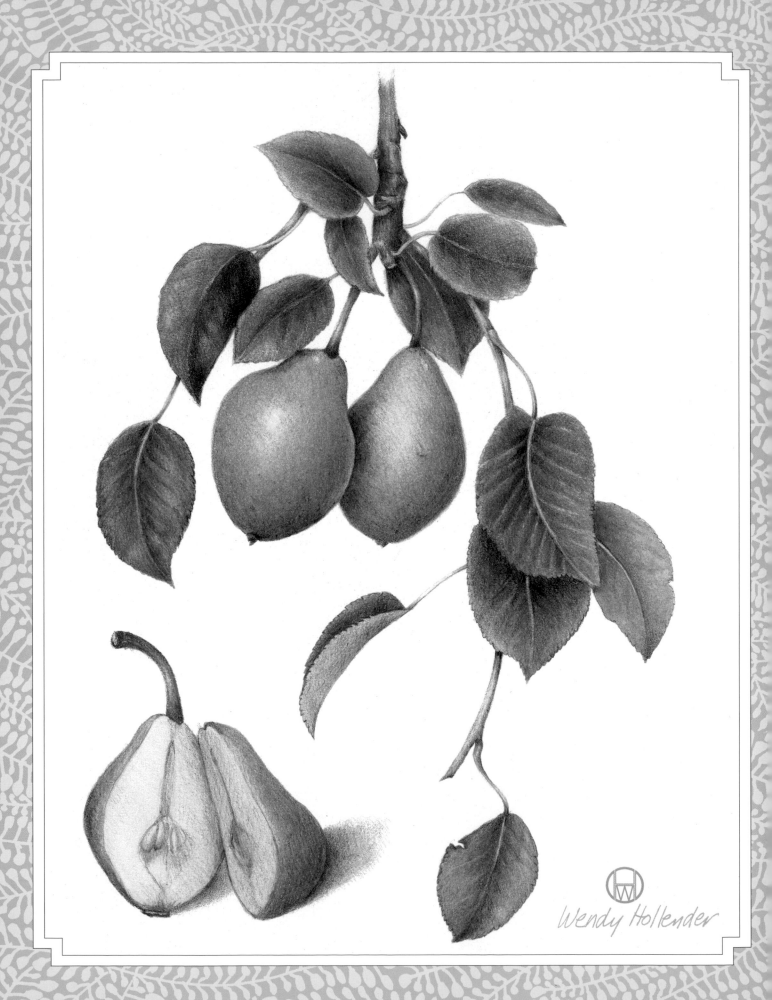

Wendy Hollender

# GATHERING YOUR
# ART SUPPLIES & MATERIALS

*Pears (Pyrus communis),*
*2005, colored pencil on*
*watercolor paper, 12 x 9 inches*
*(30.5 x 22.9 cm)*
*Believe it or not, this magnificent pear tree*
*was growing in a parking lot in Mineola,*
*Long Island. I pulled a chair right up to the*
*tree, next to the parked cars. With my simple*
*supplies of colored pencils and watercolor*
*paper, I was able to complete this entire*
*drawing while sitting near a low branch. I*
*didn't need to cut a branch and go through*
*the difficult task of keeping it in water while*
*trying to hang it in a natural position to*
*facilitate the drawing. This drawing was*
*included in the 13th International Exhibition*
*of Botanical Art and Illustration at the Hunt*
*Institute for Botanical Documentation.*

My style of botanical illustration features colored pencils. The beauty of working with colored pencils is that the materials needed are simple and few. This simplicity allows me to spend time focusing on my specimen and not be distracted by my medium. When I work I often feel as if I am "hooked up to my plant." I see the plant with my eyes, and the messages it conveys go to my brain, through my body, and out my fingers onto the paper. The process feels that simple.

My materials make my job as an artist easier. Why have it any other way? It is important to select your materials carefully. The proper pencils work for you, with precision; the proper paper helps you blend colors smoothly; and the proper magnification and light allow you to see your subject closely and easily.

With a small case of no more than twenty or so pencils, a spiral pad of paper, and a small collection of essential supplies—all of which easily fit into a small backpack—you are ready to go anywhere in the world. Whether you stay at home and focus on favorite specimens in your own backyard or travel to the jungle or the countryside, you will be prepared to create detailed colorful botanical drawings!

## PENCILS

Pencils are relatively inexpensive. Don't take them for granted, however. They are probably the most important tool you will use. And they vary greatly. My recommendations come from years of trial and error. I have test-driven many pencils and settled on these few that I know work well for me.

### Graphite Pencils

You will need at least one graphite pencil with 2H, H, or HB lead. In the beginning you will use graphite pencils for outlining your form and for toning. Later on, when you start using colored pencils, you will only make a few lines with the graphite pencil, using a light touch to scope out the shape and dimensions of your subject.

Select an excellent-quality graphite pencil. I prefer a brand called Tombow. Their Mono drawing pencil with an H lead is the best graphite pencil I have ever used. The leads are consistently smooth and neither too hard nor too soft.

### Colored Pencils

Selecting your colored pencils is a personal process. Many quality brands are available, and most art supply stores will let you try a test pencil before you make a purchase. I suggest that you try them all and see what works best for you. Key factors to consider are whether the pencil is hard or soft, its lightfastness, and whether it is wax based, oil based, or something else entirely.

Artist-quality pencils are always better than student grade. I also avoid buying pencils in a set, as the colors in a set are often not useful for botanical work. Be especially careful about the greens in a set; they are usually much too bright!

My favorite brand of pencils is Faber-Castell. For drawing, I primarily use the colors from their Polychromos line. These work for me because they are hard enough to hold a sharp point but soft enough to blend well. They have superior lightfast ratings, come in great colors, and can be easily erased. These pencils are oil based, but they do not get a waxy buildup; nor do they break or crumb up on the paper.

In addition, for the final stages of a drawing I often use pencils from Prismacolor's Verithin line. These very hard

### — SELECTING YOUR — COLORED PENCIL PALETTE

Most brands of colored pencils boast a wide range of colors, which are available as both open stock and in sets. Some sets contain as many as 120 colors. While these sets look beautiful, they are often confusing to use. I pride myself on limiting my pencils to about twenty colors. I am confident that with these twenty colors I can mix just about any color in nature. Sometimes I use an additional color when working on a particular plant (if its color is particularly unusual), but by and large I traipse through the jungle with these same twenty pencils and have never been disappointed.

Even if you ultimately decide that you prefer another brand, I recommend that you buy Faber-Castell pencils for use with this book. Throughout I refer to these pencils by their name and number. Purchasing the twenty pencils described below will make it easier for you to follow along—particularly when you do the color theory exercises in chapter 7. Of course, you can use brands other than Faber-Castell, but your pencils should be comparable in color to those on the following list.

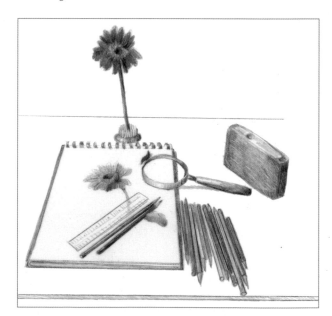

*This drawing depicts the essential art supplies—a spiral pad of hot-pressed watercolor paper, twenty colored pencils, a graphite pencil, a ruler, a magnifying glass, an eraser, and the don't-leave-home-without-it battery-operated pencil sharpener. A frog prong holds the specimen nicely in place.*

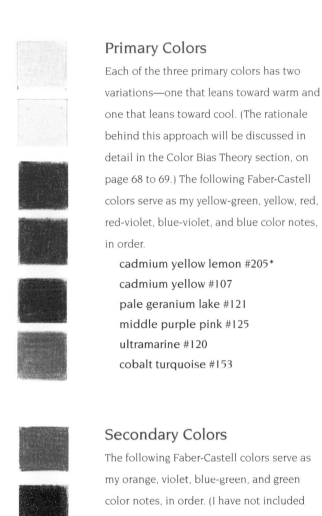

## Primary Colors

Each of the three primary colors has two variations—one that leans toward warm and one that leans toward cool. (The rationale behind this approach will be discussed in detail in the Color Bias Theory section, on page 68 to 69.) The following Faber-Castell colors serve as my yellow-green, yellow, red, red-violet, blue-violet, and blue color notes, in order.

cadmium yellow lemon #205*
cadmium yellow #107
pale geranium lake #121
middle purple pink #125
ultramarine #120
cobalt turquoise #153

## Secondary Colors

The following Faber-Castell colors serve as my orange, violet, blue-green, and green color notes, in order. (I have not included red-orange and yellow-orange color notes in this list, as I create these by blending the other colors, as discussed on page 67.)

dark cadmium orange #115
purple violet #136
permanent green olive #167*
earth green yellowish #168*

## Dark Colors

I use these colors to mix deep shades and for the first layer of toning. You'll want to buy an extra dark sepia #175 (or maybe two), as you will use this pencil most often.

dark sepia #175
dark indigo #157
chrome oxide green #278
red violet #194

## Light Colors

I use the following colors for tints, highlights, and burnishing.

white #101
ivory #103

## Earth Tones

Earth tones are abundant in nature, so having a few colors is very useful. We will learn how to mix them in chapter 7.

burnt ochre #187
Venetian red #190
light yellow ochre #183
burnt sienna #283

*With the exception of these three greens, I have chosen colors that will give me the brightest possible hue. This is important because you can always dull a color, but you cannot make one brighter. With the greens I have departed from this theory because really bright greens are rarely found in nature. If ever you need a really bright green, you can mix it with the appropriate yellow and blue, as discussed on pages 70 to 72.

pencils do an excellent job of adding precise details, providing clean edges, and burnishing a drawing. They also help me create beautifully subtle shadows. I use the dark brown #746, cool gray 70% #747.5, and black #747 Verithin pencils the most in my work.

## Watercolor Pencils

Water-soluble pencils are not my primary medium, but I do incorporate these into my drawings, particularly when I want to lay down an undertone of a color first over a large area. I like the watercolor pencils in Faber-Castell's Albrecht Dürer line because the colors are coordinated with those in the Polychromos line of pencils. In addition, the colors stay true to color when water is added, which is often not the case with other pencils. Start with a few basic colors before investing in the twenty colors discussed on page 19. The only downside to these pencils is that they are too wide to fit into my battery-operated pencil sharpener. I therefore keep a handheld sharpener with me to sharpen these pencils.

## PAPER

Paper is important! Good paper will help you create a large range of values, precisely and accurately, so buy the best paper you can get. When you are shopping for paper look first at its weight and then at its surface.

Weight is based on the thickness of the paper. The greater the number of pounds, the thicker the paper. If you buy a sketchpad with thin paper (less than 80 lb.) and work on it with colored pencils, you risk having your pencils leave impressions on the sheet of paper underneath. These may be invisible, but they can show up in your next drawing.

How a paper is pressed determines its surface texture. Hot-pressed paper is smoother than cold-pressed paper and is my choice when using colored pencils, as it blends easily and smoothly and allows for the development of deep, rich values. You will want a paper with only a slight tooth, not too rough or too smooth.

## Drawing Paper

For use with graphite pencils, I recommend Strathmore 400 series drawing paper, which comes in a spiral-bound sketchbook. Each pad contains twenty-four sheets of 80-lb. paper. This will be essential for doing toning exercises, taking botanical notes, and so forth.

## Watercolor Paper

For use with colored pencils and watercolor pencils, I recommend Fabriano Artistico hot-pressed watercolor paper. For most work, 140-lb. paper is best; however, if you plan to work with very wet watercolor, 300-lb. is recommended.

## Custom-Designed Spiral Sketchbooks

Spiral pads of heavyweight, hot-pressed watercolor paper are not easy to find. To meet this need, I make my own spiral-bound sketchbooks that alternate between two weights of paper—one page of Strathmore 400 series drawing paper for botanical note taking and sketching with a second page of Fabriano Artistico 140-lb. hot-pressed watercolor paper for making colored pencil illustrations. I've also included a thick, durable cardboard backing for support. These spiral pads are available to my students for purchase. (See Sources, page 143.)

## Matte Film

I use this "paper" for the advanced color pencil work that I explain in later chapters. It is optional; you do not need to purchase this item. Matte film is challenging to use because it saturates with color much more quickly than does watercolor paper. However, because it is transparent, matte film also allows you to position drawing paper underneath and use a graphite drawing as a guide for your colored pencil drawing. My favorite brand is Grafix Dura-Lar Matte Film because it accepts many layers of color and is heavyweight.

## ADDITIONAL SUPPLIES

In addition to your pencils and paper, you will need a variety of additional supplies, many of which you may already have.

## Erasers

There are two main types of erasers—kneaded erasers and plastic erasers. Kneaded erasers should be small, for easy kneading. If you buy a large kneaded eraser, pull off a small, manageable piece and put the rest away. I carry kneaded

erasers with me, always, and use them the most for small jobs and to remove smudges on my paper.

## Pencil Sharpeners

When working with colored pencils, it is crucial to have good pencil sharpeners. In fact, you cannot do good work without them. For use in the field, I recommend the Panasonic battery-operated KP-4A pencil sharpener and (for backup) a handheld pencil sharpener. For work at home, there is nothing better than an electric pencil sharpener.

## Ruler

I recommend a 6-inch, clear plastic (transparent) ruler for measuring specimens. (Larger rulers tend to get in the way for this purpose, though an 18-inch ruler is good to have for making ruling lines on your paper.) The best one that I've found—as it allows you to see through to measure accurately, yet has clear, readable measurement markings—is the C-Thru Ruler.

## Magnifying Glass

A handheld magnifying glass with large surface (at least 3 inches in diameter) allows you to inspect the parts of your plant before, and also as, you draw. Magnification should be at least three times actual size, but the more magnification, the better. Seeing and understanding every little part of a plant is the basis of precise and accurate botanical drawing.

## Dissecting Microscope

A dissecting microscope is not essential, but it is amazing to have for studying plant morphology. A wide range of dissecting microscopes are available. If you can get one that magnifies your specimen ten to thirty times its actual size, that is excellent. When using a dissecting microscope, use the light from above (except when viewing cross-sections).

## Gooseneck Lamp

Having a gooseneck lamp on your work table at home will help you establish a single light source.

## Assorted Holders and Accessories

Holders will help you keep your cut specimens fresh as long as possible. These may include small vases or jars, which can be used with or without a florist's frog prong. (A frog prong is a small piece of metal, glass, or plastic with perforations or spikes for holding flowers in place.)

## Erasing Shield

These are very handy for cleaning up stray lines in difficult-to-reach places in your final drawings. The shield has small openings that allow you to erase only what you want and keep the remainder of your art protected.

## Cutting Instruments

A knife or garden clippers is essential for cutting specimens. A single-edge razor blade is critical for dissecting specimens.

## Waterbrush

This special brush contains water in an attached well. When using watercolor pencils, this tool is useful for blending the pigments.

---

### — A NOTE ON SUPPLIES —

Art supplies are always changing. I encourage you to pay attention to what your materials are doing and to be open to exploring other materials that may work better for you. In the beginning, use the best materials you can afford, and keep it simple. Start with what I suggest, and later on you can try new materials and different methods. My goal is to teach you the specific techniques that I have developed and that have worked for my students I have been teaching for years. It is not the only way to work—there are as many techniques and materials available as there are plants in the world! The important thing is to develop a way of working that feels natural and comfortable for you and eventually gives you the results you hope to achieve.

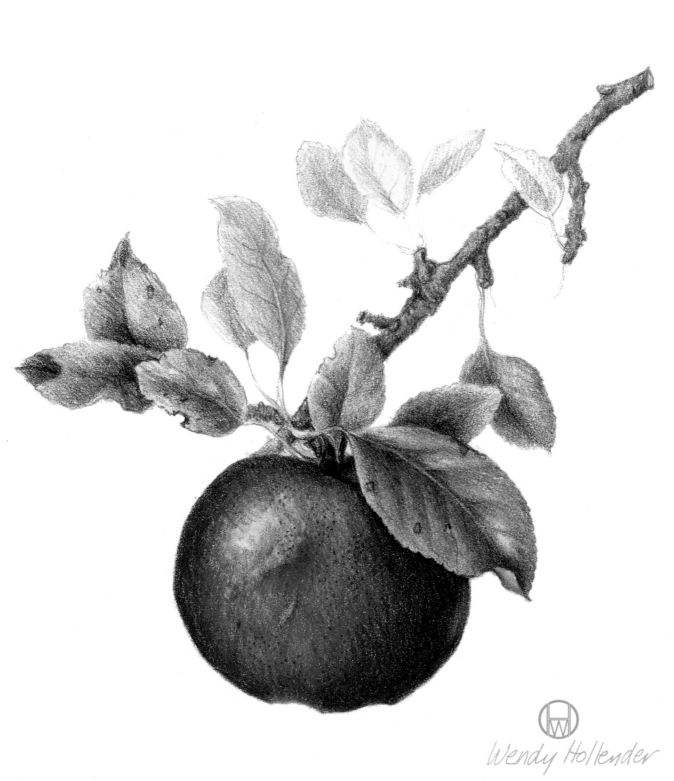

Wendy Hollender

# ESTABLISHING
# VALUE AND FORM

*Apple (Malus domestica), 2005, colored
pencil on watercolor paper,
12 x 9 inches (30.5 x 22.9 cm)
This apple was from a very old apple tree on
Nantucket. Understanding how variations
in values can make a form such as an apple
look three-dimensional is an exciting
concept to learn.*

The term *value*, with all of its variations (such as *tone* or *shade*), is used to describe gradations of light and dark in a drawing. To create the illusion of three dimensions on a two-dimensional surface, it is important to vary your values according to how a specific light source hits your object. The lightest value, the highlight, describes the highest point of the object. The darkest values are the areas hidden from the light source, referred to as the shadows.

On a round object, such as an apple, using a smooth transition of value will create the correct illusion. When describing an object with sharp surface changes, such as a box, the values change abruptly. A crumpled T-shirt or piece of fabric has both subtle and abrupt changes that describe its complex surface.

As an artist, if you vary the values in your work from very dark to very light it will help make your forms look three-dimensional. When first learning about value it is best to completely forget about the color of an object. Think of a black-and-white photograph with a complete range of values from dark to light. It is an almost magical experience to tone an object gradually and create something that looks so real that it seems as if you can lift it off the paper!

# OBSERVING VALUES AND SURFACE CONTOURS

This exercise will help you understand the importance of using a range of values to describe surface contours. When you first start to look for values on form, it is best to work with neutral-colored objects so that the color of the object does not become a distraction.

## PROCEDURE:

Take a plain white T-shirt and lay it out on a flat surface, such as a table. Set up a light source in front of your shirt (as shown on page 27) or use natural light that is coming from the upper left and hitting the T-shirt at a 45-degree angle. Smooth out the surface of the shirt, as if you are ironing it with your hands. Notice that it is one value (white, more or less), without shadows. All flat surfaces have very little variation in value because their contour, or shape, is flat.

Now crumble the T-shirt with your hands. Step back and look at all the creases you have created. What you see are areas with different values—from white to almost black. Even though you know the T-shirt itself is solid white, what you see are areas of various contours and values.

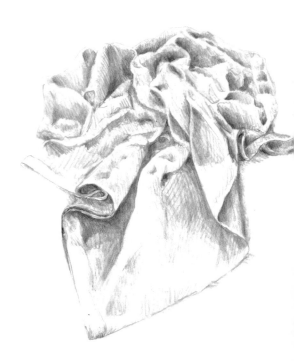

This is a drawing of a crumpled T-shirt. Notice how many varied values are used to describe the contours of the surface.

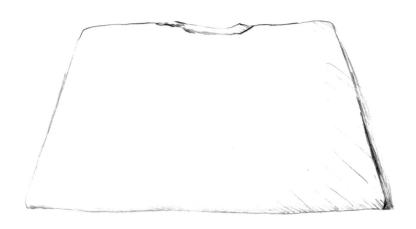

This is a drawing of a folded T-shirt. Notice that hardly any values are used to describe its surface because it is flat.

# SHARPENING YOUR PENCIL

Having a sharp point on your pencil is crucial to being able to maintain a light touch and lay down an even layer of value. During the final stages of a drawing it is also critical for adding in subtle details and line. I cannot overstress how important this is to the success of your work.

## PROCEDURE:

Hold the pencil firmly in one hand and the pencil sharpener in your other hand. Insert the pencil at a 90-degree angle, straight into the hole. Press firmly and evenly as the pencil sharpens. As you remove it from the sharpener, twist the pencil against the spinning blade inside slightly so you get a fine point.

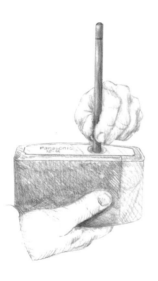

It may seem obvious, but really pay attention to your point when sharpening your pencil.

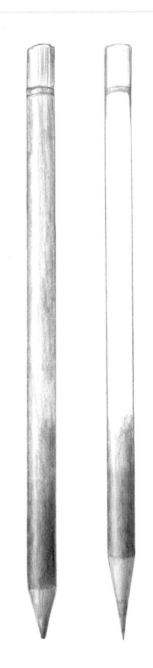

Notice the different between a dull pencil point (left) and a sharp pencil point (right). Look at your point after you use your sharpener and make sure it is sharp.

**WHAT YOU'LL NEED:**

a battery-operated pencil sharper
a dull pencil

## NOTE:

Though the terms *value* and *tone* are interchangeable, in this book I use the noun *value* to describe the lightness or darkness of a shade or color (e.g., "The value of this color is very dark"). Likewise, I generally use the verb *tone* to describe how you will be drawing something (e.g., "Tone your form using a upper-left light source").

# RENDERING NINE VALUES, FROM DARK TO LIGHT

To describe form three-dimensionally, you need a wide range of values. This exercise shows the gradual transition from dark to light that will help make your forms appear three-dimensional.

## PROCEDURE:

Toward the top of the page, draw nine sequential (1 x 1 inch) squares very lightly. Tone these nine segments from dark to light with distinct differences in value from one square to the next. See how dark you can make the first square, on the extreme left. Note that the segment at the extreme right (the ninth square) will be the color of the paper (the lightest value), and the square in the middle (the fifth square) should be a shade between the two extremes.

Now, toward the bottom of the page, draw a 1 x 9-inch rectangle. Try to make a continuous value, from dark to light, with no distinct differences in value from one area to the next. When applied to objects, even toning (graduated values from dark to light) creates the illusion of three dimensions.

---

### WHAT YOU'LL NEED:

a graphite pencil

drawing paper

an eraser

a ruler

---

### — CREATING A — NINE-STEP VALUE BAR

After completing this exercise, create a second nine-step value bar—this time using a dark sepia #175 pencil and watercolor paper. Once you are finished, trim away the extra paper and then use a hole puncher to create a hole in each of the nine squares. This tool will become extremely useful during the exercises in chapter 7.

dark          medium          light

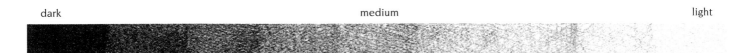

This nine-step value bar features clear distinctions between each value.

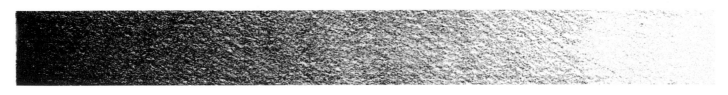

This is a continuous value bar, where the values change gradually.

## THE IMPORTANCE OF A SINGLE LIGHT SOURCE

To make your forms look three-dimensional, render your objects as though the light is coming from one direction only. In terms of setup, this means you should make the primary light source bright enough to dominate over any other sources. One technique for achieving this is to put your objects in a box and have a light shine into the box.

The most effective lighting for botanical drawing comes from the upper-right or upper-left side *in front of your objects* and shines down at about a 45-degree angle. Most right-handed people work with light from the upper-left side and left-handed people often prefer light from the upper-right. (These preferences prevent the artist's hand from casting a shadow on the area he or she is drawing.) Even though I am left-handed, I have taught myself to work with my light source from the upper-left side because most people are right-handed, and for learning and teaching it seemed easier. With practice, you will eventually learn to visualize this lighting even when it is not present.

The paper itself is always the lightest area, creating the drawing's highlight. Values get darker as the object is exposed to less light. Three-dimensional objects on a surface will cast a shadow where the object is blocking the light. The shadow's direction depends on the location of the light source. If the light comes from the upper left, the shadow will be on the lower right. Shadows will be less obvious on darker surfaces. Illustrations with upper-right or upper-left light sources appear to be more three-dimensional because the tonal range from highlight to shadow is more visible.

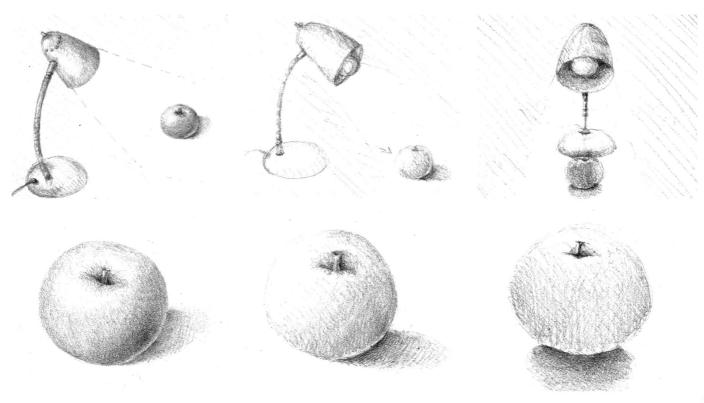

(Top) For botanical drawing, the most effective lighting either comes from the upper-left (shown here) or upper-right side. (Bottom) The light for this apple came from the upper left. Notice how clear and three-dimensional this apple looks.

(Top) Horizontal lighting washes out one side of the object. (Bottom) The light for this apple was horizontal. Notice how the left side of the fruit is washed out.

(Top) Backlighting almost hides the highlighted area of the object. (Bottom) This apple was backlit. Notice how the shadow is directly below the drawn object and the apple appears flat.

# TONING A CIRCLE TO LOOK LIKE A SPHERE

Learning to tone a sphere is an essential skill—both for gaining control of your technique for toning and for understanding the light source on round forms.

## PROCEDURE:

Set up the sphere on a light-colored surface and illuminate it with a gooseneck lamp placed on the upper-left side at a 45-degree angle. Then follow these steps:

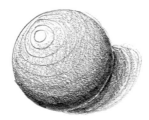

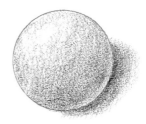

**1** Using your graphite pencil, very lightly draw a circle with a 2-inch diameter. Mentally divide the circle into four equal sections. The highlight will be in the center of the upper-left section. Neither draw the quadrants nor outline the highlight (as I've done here); just understand where these elements will be.

**2** To help you visualize the sphere's three-dimensional surface, I have drawn its surface contours. These not only indicate the roundness of the sphere, but they also break up the form into nine segments, each of which should be toned according to your nine-step value bar. Study these two illustrations, but do not draw surface contours on your circle.

**3** Now begin toning your circle. With your graphite pencil, start with the lower-right area, where it appears darkest on your model. Tone the rest of the circle, leaving the highlighted area untouched.

Note that the shadow's darkest area is underneath the edge of the sphere. It gradually fades away as it gets farther from the sphere. Make sure to leave a tiny, lighter area on the edge of the sphere closest to the shadow; this will define the edge.

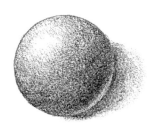

Continue adding layered strokes, trying to achieve a range of nine values, from light to dark (highlight to shadow), with no clear distinction between values. Avoid creating swirling strokes when toning; even though they follow the contour of the sphere, they are confusing. Try to keep your toning even and smooth.

Notice how three-dimensional your sphere looks once it has been toned. The cast shadow should help this illusion, as it creates the feeling that the sphere is sitting on a table.

TOP:
*Black Walnut (Juglans neotropica) (detail)*, 2007, colored pencil on watercolor paper, 11 x 7 inches (27.9 x 17.8 cm). *The outer shell of the black walnut has strong notches on its surface, but in terms of toning it is still a distinct sphere.*

## — TONING THE OTHER — THREE BASIC SHAPES

With this last exercise you've learned that by introducing smooth tonal variations a circle can become a sphere. Now try your hand at transforming the other three basic shapes, simply by adding value.

When value is added to the outline of a cup, it suddenly clearly describes the inside and outside of the object.

A cone shape uses values similar to those of a cup. Practice seeing values by identifying the highlight, the midtones, and the shadows of various objects.

A cylinder is an important form—one that occurs frequently in nature. Practice and memorize the "formula" for depicting light on this shape.

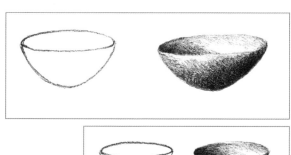

A cup

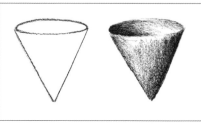

A cone

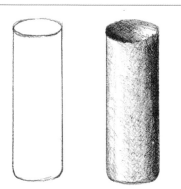

A cylinder

# TONING A SPOON

Once you begin to see the world as an artist, it's amazing how many common objects can become the basis for practicing your drawing skills. Here is one that will expand your understanding of how light responds to concave and convex surfaces, which will give you the foundation you need for drawing petals.

## PROCEDURE:

Observe your spoon with a single, consistent light source to see the way the light hits the surface contour. The inside of the spoon is a concave, bowl-like surface.

To help you draw your spoon life size, lay it directly on your drawing paper. Then, using your graphite pencil, lightly and carefully draw an outline of your spoon.

Now, focus on articulating the subtle contours of the spoon. Start by drawing a thin outer edge on the left side of the spoon to show its thickness. Notice that this edge is very light because it is the highest point on the spoon and receives the most light. Note also that it is very dark right below this edge, as this area is in shadow. Gradually the values get lighter as they approach the bottom of the spoon. As the values start to go up the right side of the spoon, there is a highlighted area and then the values get a little darker before the edge of the right side of the spoon.

Start to tone your drawing. Use the dark sepia pencil for this if you like, or stick with your graphite pencil.

Turn the spoon over and observe the convex side of the spoon. Note that, in terms of toning, it is similar to a sphere. Draw this side of the spoon and tone the form gradually.

### WHAT YOU'LL NEED:

a white plastic spoon

a graphite pencil

a dark sepia #175 pencil (optional)

drawing paper

an eraser

a gooseneck lamp

### NOTE:

All tonal exercise from here on can be done either entirely with a graphite pencil or the outline can be done with graphite and then you can switch to your dark sepia #175 pencil for the toning part of the exercise. If you are excited and want to get to color right away, do the toning in these exercises with the dark sepia pencil so you can get used to this pencil. But if you find color distracting and want to first really understand toning, you can just use a graphite pencil the whole time.

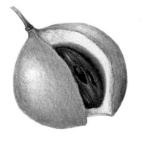

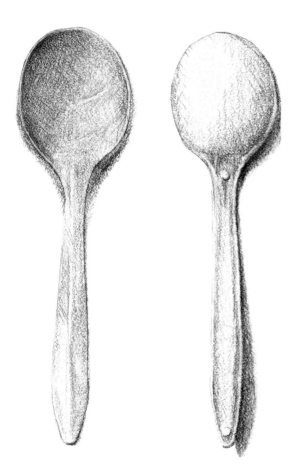

Concave (on the left) and convex (as on the right) surfaces are important to memorize with your standard, upper-left light source. Convex surfaces are similar to the surface contour of a sphere.

OPPOSITE:
*Nutmeg and Mace (Myristica fragrans) (details)*, 2007, colored pencil on watercolor paper, 18 x 12 inches (45.7 x 30.5 cm)
*This plant's fruit produces the spices nutmeg and mace. The red-colored fibrous skin makes mace, and the innermost hard brown nut is the nutmeg. Nuts are excellent subjects to practice concave and convex shapes.*

## — TONING —
## INDIVIDUAL PETALS

Now that you've rendered the concave and convex surfaces of a spoon, expand and apply your skills to a botanical subject—the petals of a flower. Tulip and magnolia petals are perfect for this exercise. Furthermmore, a white flower will make it easier to observe the values.

The petals below illustrate the surfaces often seen in tulip petals. However, not all tulips are the same. Notice the subtle center vein in the tulip petals at the bottom, which needs to be drawn and toned as well.

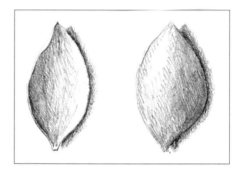

Tulip petals feature concave (left) and convex (right) surfaces.

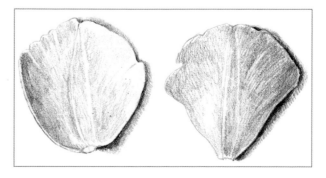

Some varieties of tulips also have center veins.

 # Examining the Four Basic Shapes

Four shapes—sphere, cup, cone, and cylinder—are similar to almost all forms found in nature. Understanding the surface contour of these shapes and the way they are illuminated by a single light source is critical to being able to draw similar shapes in nature.

## Procedure:

In the exercise on pages 28 to 29, you practiced toning a sphere. Now it is time to use the same procedure to tone a cup, a cone, and a cylinder. Since these shapes are hollow, this exercise allows you to practice toning the inside of the form, which is helpful since this emulates the structure of many flowers.

Examine and draw your objects one at a time. As before, set up each object on a light-colored surface and illuminate it from the upper left. Try to remember at all times when drawing these shapes that you are trying to convey their three-dimensional quality. Tone very slowly, and gradually shift your values as your eyes move across each shape. I sometimes pretend that my pencil is a small insect slowly crawling across each shape. Notice on the inside of a cup, cone, or cylinder that the darkest area is right next to the lightest part of the outside of each form. This is important to pay attention to, as contrast in values is used to convey the three-dimensional quality of forms.

Once you memorize how to tone the four basic shapes, you can use this toning guide when you are drawing more complex but similar forms in nature. This skill has numerous benefits. For instance, if your form does not have the optimum light source, you can put it in!

Often, it is not possible to light a delicate flower perfectly. First of all, a hot light might make the flower wilt before you can draw it; or if the petals are translucent, the light might show through the back, or the pigment patterns on the petals might be varied and distracting. For these reasons it is often preferable to work from a light source in your head. You will still look very carefully at your flower for its form, color, and details, but the light source you render will be an imagined one. You will still want to work in a well-lit environment, with daylight whenever possible, so you can see details clearly.

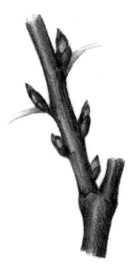

*American Elm (Ulmus americana) (detail), 2005, colored pencil on watercolor paper, 16 x 12 inches (40.6 x 30.5 cm) Branches with dormant buds are excellent subjects to practice thinking of cylinders and cone shapes.*

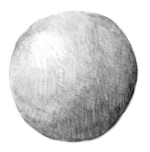
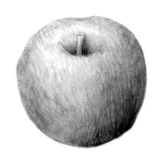

Mastering the rendering of a sphere leads to being able to draw apples, blueberries, and tomatoes.

Mastering a cup shape helps when depicting tulips or trumpet-shaped flowers such as campanulas.

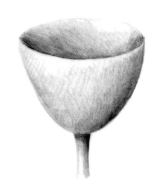
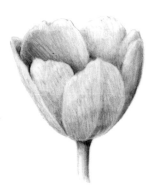

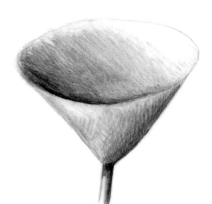
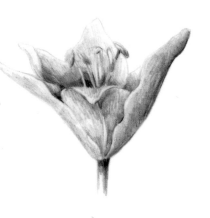

Mastering a cone shape is essential for capturing the likeness of a lily.

Mastering a cylinder is invaluable for rendering stems, branches, and stamens.

# TURNING A SPHERE INTO AN APPLE

An apple is similar to a sphere—except that it has a recessed area in its top where the stem is attached. By visualizing a sphere with a cone inside it and a cylinder inside the cone, you can turn those three simple forms into the more complex form of an apple.

## PROCEDURE:

Light the apple from the upper left so that there are obvious highlights and shadows. Using your ruler, measure the height and width of your apple. Then measure where the stem is attached. Now follow these steps:

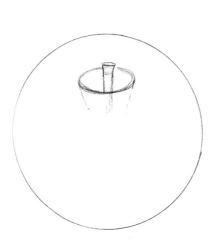

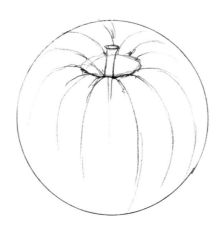

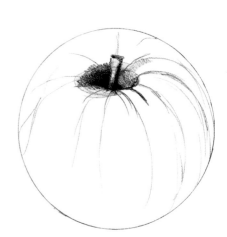

*1* Using your graphite pencil, draw a circle, a cone, and a cylinder. An apple is different from a sphere in that the lightest area forms an arc around the rim of the recessed area that holds the stem. You will have a highlight in one or two areas of this arc.

*2* This drawing features contour lines that are meant to help you to visualize the three-dimensionality of the apple's surface. Do not copy these contour lines onto your drawing. Instead, study this image. It should help you build up the values more accurately on your drawing.

*3* Tone the recessed area and the stem of your apple. The skills you mastered earlier in toning a (hollow) cone and a cylinder should come in handy now. Notice how the highlight of the cylinder falls just inside the left edge, while the highlight for the cone falls on the right.

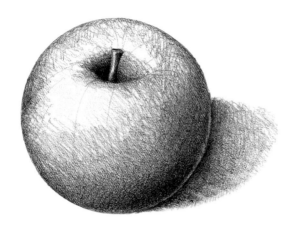

Now tone the remaining parts of the surface of your apple. For the near half of the apple (i.e., the part in front of the stem), follow the basic guidelines from the earlier exercise, when you turned a circle into a sphere. Be sure to use value to show how the main front area of the apple is rising above the recessed area—first becoming lighter in value and then, as it goes away from the light, becoming darker. For the far half of the apple (i.e., the part behind the stem) the values also start out darker and then get lighter and after that start to get darker again as they go away from the light.

Make sure to render the reflective highlight at the dark edge of the apple. A reflective highlight is never as light as the primary highlight on the object. It should be toned slightly so as to remain deeper in space and not compete with the main highlight. Note: I created this apple using a contour of a perfect circle to emphasis the similarity. However, apples normally have slightly irregular contours, as you will see in the apple in the next exercise.

And finally, render the shadow cast by your apple. Lightly draw this without creating an obvious outline or edge, especially where it fades away. The shadow should sit under the apple and not appear to be more important than the apple.

## — RENDERING —
## SHADOWS ACCURATELY

Learning how to render shadows accurately begins with close observation. Examine the shadow cast by an apple by moving a gooseneck lamp around the apple and watching where the shadow is cast. The lower you position the lamp, the longer the shadow will be. In addition, multiple light sources will cast multiple shadows.

When rendering a shadow next to (and under) an object, it is important to have a thin reflective highlight on the darkest edge of the object itself, closest to the shadow. This creates contrast, which will appear to push the object forward in space and the shadow back, where it belongs. The drawing to the left shows an accurately rendered shadow.

Some people are afraid to draw shadows right up to the edge of the object, so they leave a white halo, as shown below. This is not as convincing as having the darkest shadow right up to the edge of the object and the reflected highlight on the object itself.

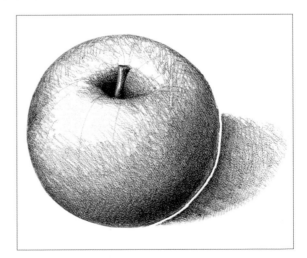

An inaccurately rendered shadow

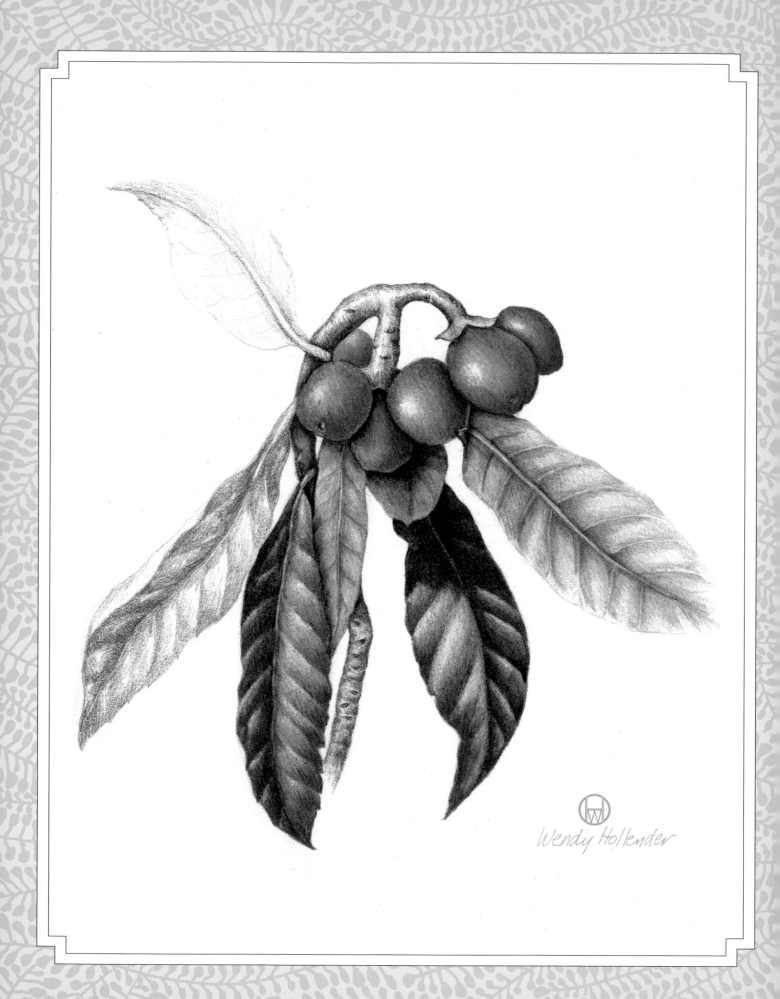

Wendy Hollender

# ADDING COLOR TO A TONED FORM

*Loquat Tree (Eriobotrya japonica),*
*2006, colored pencil on watercolor*
*paper, 12 x 9 inches (30.5 x 22.9 cm)*
*I picked this branch on a hillside in*
*Cinque Terre, Italy, and spent pleasant days*
*drawing it while sitting on the beach.*

Color is seductive. I like to add color to my drawings immediately. Most students feel the same way. I often start a basic class with toning a crabapple in graphite and then immediately show students how to tone that same crabapple in color. I do this for two reasons: First, everyone loves using color; but more important, experience has shown me that even students who have learned toning on form immediately forget the importance of rendering three-dimensional form with values and a light source when they begin working in color. The minute they start to work in color, these techniques fly right out the window! Their apple will be solid red, brilliant in color, but with no distinction between values of red. Thus it will look flat.

I start teaching color early on in the process to continually reinforce the importance of value first, color second. In this drawing of loquat fruit, I focused on making the fruits look three-dimensional by emphasizing highlights and shadows. Notice how the branches are toned like cylinders. Though the drawing is in color, it has a distinct range of values, from light to dark. By rendering my first layer of the drawing with dark sepia, I was able to "feel" the forms first before adding color.

# PRACTICING BASIC COLORED PENCIL TECHNIQUES

Before you begin to render forms in color, you'll want to practice two essential techniques for using colored pencils—toning and burnishing.

### PROCEDURE:

While you are first getting to know your colored pencils, it is important to experiment with them. As you read the text that follows, test the ideas discussed on your own piece of paper. Be creative! Try your own color combinations. Consider alternative ways of holding your pencils. Vary the pressure that you put on your pencil tip. This is your time to just have fun and see what effects you can achieve with your pencils.

Colored pencils are translucent and can be blended together to make other colors and values. For example, yellow (cadmium yellow lemon #205) mixed with blue (cobalt turquoise #153) will make a bright, clear green (more about this in chapter 7). Likewise, cobalt turquoise #153 can be mixed with both dark sepia #175 and white #101 to create a range of values of blue, from dark to light. Colored pencil drawings have more dimensionality when the colors are blended to make different hues and values, rather than when a single colored pencil is used.

To achieve rich, saturated results, colored pencils, like watercolors, should be applied in light layers of color. There is one exception: highlights. The white of the paper is used for the highlights because white or ivory pencils will not make white highlights over darker values.

A smoothie blended bar, showing cadmium yellow lemon #205 mixed with cobalt turquoise #153 to make green.

### Toning

In graphite you go from light to dark with one pencil by laying down more and more graphite to get increasingly darker values. In colored pencil, you select your main color and then add darker pencils to create darker values and lighter pencils to create lighter values. Each color, regardless of its value, should be saturated with layers of pencil pigments. The end result will be a rich color that is solid, rather than one that allows the texture of the paper to show through.

When toning, keep a relaxed hand at all times. Do not grip the pencil tightly. Colored pencils are made of pigments, binders, and either wax or oil. This allows the colors to be applied smoothly (called a "good lay-

This value bar shows cobalt turquoise #153 mixed with dark sepia #175 to the left and white #101 to the right.

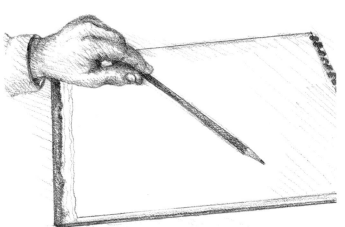

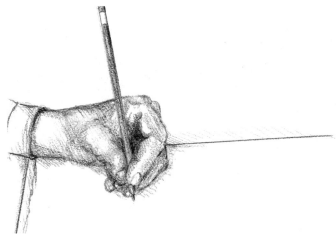

In your first layers you may decide to hold your pencil this way. However, soon your fingers will start to grasp the pencil lower down so you have more control.

Grasping the pencil close to the point gives you more control, which is helpful when rendering detail and when adding more pressure. Remember to always hold your pencil with a light grip, not too tightly.

down"). Using excessive pressure will build up the surface too quickly, making it difficult to blend colors smoothly. Very light pressure in many layers creates deep, rich colors.

Sharpen the point frequently and hold the pencil near its back end and at a low angle to the paper. Some of my students find they are more comfortable drawing with the pencil if they hold it the same way they do when they are picking it up, rather than the way they hold it when writing.

Gently apply a thin layer of color, switch pencils, and blend the second color over the first. Continue alternating the colors until the desired saturation is reached. Keep sharpening the pencils and gradually use more of the point with small, circular strokes. I prefer to blend colors until there is almost none of the original color of the paper showing. At this stage I start to burnish the area.

## Burnishing

Burnishing is like polishing. It smoothes and intensifies colors. When you have reached the point where almost none of the original paper color is showing through, it is time to burnish. Use ivory #103, white #101, or a colorless blender pencil. Other light shades can also work well—or simply continue to use your main-colored pencil, pressing hard. Use

small, circular strokes with heavy pressure. This creates a smooth, blended surface and eliminates the paper color and texture. A white pencil will lighten and brighten the colors. An ivory pencil will lighten and slightly dull colors. The colorless blender will brighten colors but not lighten them. After you burnish an area you can reapply some of the darker color on top. Work slowly and carefully.

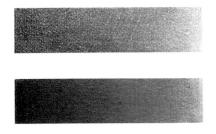

Here is a before-and-after image of what burnishing does. Notice the texture of the paper in the first image. After burnishing, the colors are smoother and richer; in addition, none of the paper color shows through.

Pay attention to what is happening on the paper, and make adjustments in your technique as needed. When layering on darker colors use a darker color to burnish. This will produce deeper values. Burnishing polishes and blends colors, creating luminous, intense color with a painterly look not usually associated with colored pencil.

# CREATING A VALUE BAR IN COLOR

This exercise uses three colored pencils—middle-tone green, dark sepia, and ivory (or white). These colors will be blended to create the transitions from darkly shaded areas to light areas (the highlights).

**WHAT YOU'LL NEED:**

a graphite pencil

an earth green yellowish #168 pencil

a dark sepia #175 pencil

an ivory #103 or white #101 pencil

watercolor paper

an eraser

a ruler

## PROCEDURE:

Using your graphite pencil, very lightly draw a ½ x 3–inch rectangle. Then follow these steps:

*1*

Apply a layer of green (about 1 inch long) in the middle of the rectangle, and then gradually tone the rectangle in each direction until the color disappears. Use the same technique you developed when creating a continuous value bar on page 26.

*2*

Begin adding dark sepia to the left edge, blending into the green area very lightly. This step is similar to applying the first layer when creating a continuous value bar, darkest on the left side and getting lighter toward the right.

*3*

Add ivory or white from the right side, blending toward the green. In this layer you are working from the lightest areas toward the darker areas. Only blend your light pencil about a third of the way toward the center.

*4*

Continue working in layers, using all three colors until the rectangle is saturated with color. Eventually none of the paper will show through. This technique will produce rich areas of color and the smooth transition from dark to light.

# TONING A CIRCLE IN COLOR
## TO LOOK LIKE A SPHERE

Using your colored pencil techniques, now try transforming a circle into a green sphere. You will do this by using the Six-Step Technique for Toning an Image in Color, described below. Once you know this technique, you can apply it to any shape and color.

## PROCEDURE:

Set up your sphere as you did for the exercise on pages 28 to 29, with an upper-left light source. Then follow these steps:

**1** Examine your value bar. Notice how it ranges from dark sepia on the left to white on the right. For this exercise you will essentially be re-creating the range of values in this bar, applying the technique to a sphere.

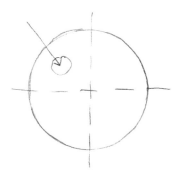

**2** Using your graphite pencil, draw a circle approximately 2 inches in diameter. Mentally divide the circle into four sections, with the highlight being in the center of the upper-left quadrant. (Don't draw the quadrants or outline the highlight on your paper; I've done this here to help you visualize the position of the highlight.)

**3** In an unobtrusive area of your drawing paper, create a thumbnail sketch with graphite pencil. (A thumbnail sketch is a small drawing done quickly to help visualize your game plan for your drawing. It is used here to describe your light source plan, and later in the book it will be used to plan compositions.) You can also refer to your toned drawing of a sphere for comparison. Having this as a guide, you are now ready to begin the real drawing.

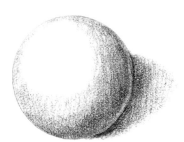

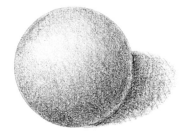

**4** Using your dark sepia #175 pencil (not your graphite pencil), tone your sphere, including the shadow on table surface. (You might want to refer to pages 28 to 29 to refresh yourself on how to do this.) Remember to work on the image in layers, building up color gradually. Stop when your sphere is saturated to about 25 percent of its final value.

**5** Apply the earth green yellowish #168, blending it both into the sepia and into the lighted area. Make sure to leave the paper color for the highlight, and remember to maintain a range of all nine values, even in color.

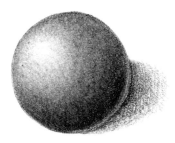

### NOTE:

Do not use a graphite pencil for Step 4. Graphite will smudge and dirty your colors, while a dark sepia #175 pencil will blend nicely with your other colored pencils.

**6** Introduce your ivory #103 or white #101 in the lighter areas, and gradually build up all three colors until the sphere is saturated. Refine the details (like the reflective highlight next to the shadow). Use either white or ivory to blend and burnish the image. Even after you start to burnish you can go back over this layer with the other colors to intensify the effect.

# Toning an Apple in Color

Now take a simple form in nature—a modified sphere, as exhibited by an apple—and use the Six-Step Technique for Toning an Image in Color to add value and color.

## Procedure:

Set up your gooseneck lamp so that it will illuminate your apple from the upper-left side. Continue as outlined below:

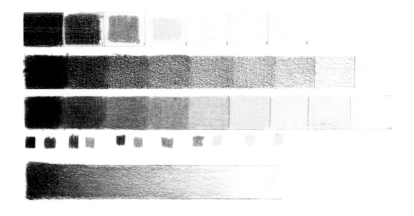

Select the colors that you will need to render your particular specimen. My Granny Smith apple was distinguished by various shades of green and yellow. So I selected earth green yellowish #168 to represent the local color of the apple, permanent green olive #167 to represent the darker values, and cadmium yellow lemon #205 to represent the lighter values. I also chose dark sepia #175 and ivory #103 for blending the darks and lights, respectively. I first made squares of each individual color, and then I made a reminder bar with dark sepia #175, showing nine values. After that I made individual steps to imitate the colors of the apple, including shadows and highlights. Below this band I made little squares to show what colors I used in each segment. Last, I made a continuous smooth blend in color.

**NOTE:**
Now that you have practiced round forms in color, you can continue to try different round forms in various colors. Some suggestions are oranges, lemons, and smooth nuts. Then you might move on to slightly more complex shapes, such as pears, gourds, and radishes.

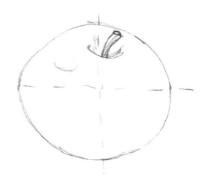

**2** Measure the apple. Then, using your graphite pencil, lightly draw contour lines to help you to visualize its shape. As you did on page 41, find the highlight on the apple by (mentally) dividing it into four equal sections. The highlight will be in the center of the upper-left section. Tone the depression around the stem and the shadows cast by the stem and the apple.

**3** In an inconspicuous location of your paper, create a thumbnail sketch of the apple. By now, you may not actually need to make the thumbnail sketch. This step is to remind you to think about light source and tones on your form before you dive into your color!

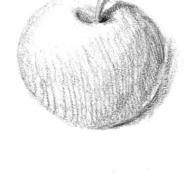

**4** Now begin your drawing, using your dark sepia pencil. Tone the lower right portion first to indicate light coming from the upper left. Add in a bit of a shadow and reflective highlight on the right side as well. There may even be a bit of a cast shadow from the stem on to the apple.

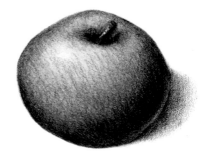

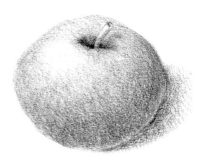

**5** When you are satisfied with your toning, gradually apply layers of the dominant colors over the toned drawing. Maintain a range of values from dark to light.

**6** Continue layering colors and begin to burnish the lighter areas with ivory. As described earlier, burnishing smoothes and blends the colors, making the transitions appear more natural. Clean the edges of your drawing with your kneaded eraser. Add any details (such as the stem) and finish burnishing. Use the Verithin pencils to sharpen blurry outer edges of your apple and also for a bit of extra burnishing, especially in the darker areas.

*Akee (Blighia sapida), 2009, colored pencil on matte film, 11 x 8¹⁄₂ (27.9 x 21.6 cm)*
*This sketchbook page was done in March on location in St. Croix at the Virgin Islands Sustainable Farm Institute. Their talented chef made a delicious akee bruschetta from the only parts of the fruit that are not poisonous—the ivory-colored, brain-like flesh.*

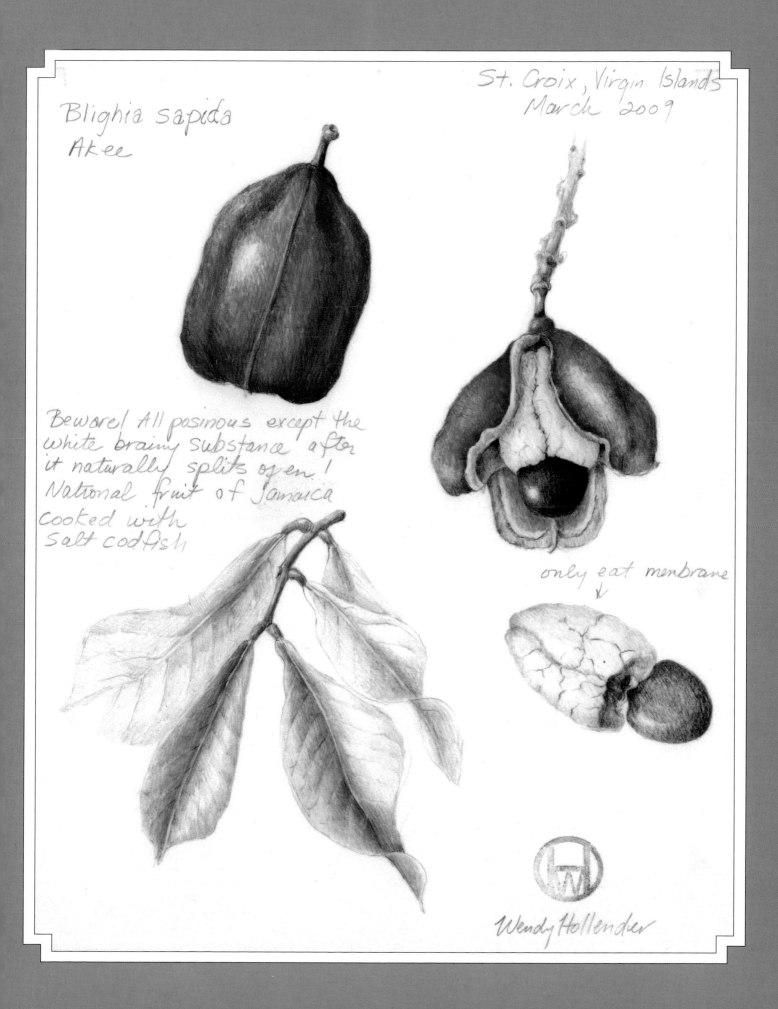

Blighia sapida
Akee

St. Croix, Virgin Islands
March 2009

Beware! All poisinous except the
white brainy substance after
it naturally splits open!
National fruit of Jamaica
cooked with
salt codfish

only eat membrane
↓

Wendy Hollender

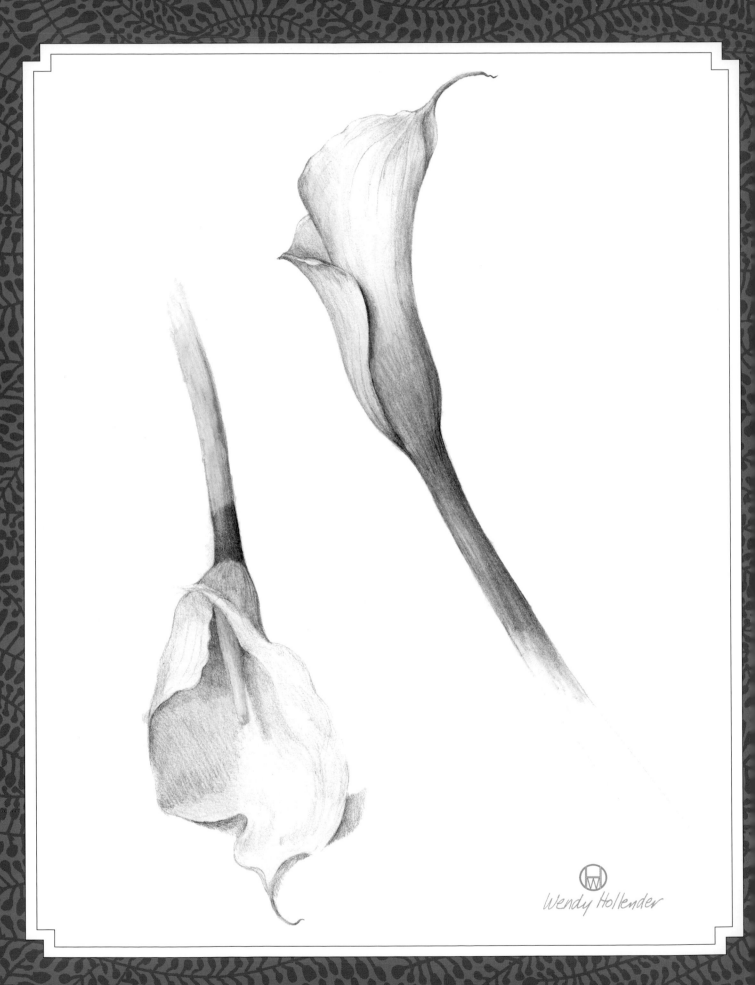

Wendy Hollender

# Establishing Perspective

*Calla Lilies (Zantedeschia aethiopica),
2008, colored pencil on watercolor
paper, 14 x 11 inches (35.6 x 27.9 cm)
Perspective is all about your view of a subject.
I drew two distinct views of these white
calla lilies to help describe the unique nature
of this flower. The first view shows the
outside of the flower, and the second invites
you inside the flower to view its unusual
structure.*

Perspective is a technique of drawing that allows the artist to draw objects that appear in three dimensions on a two-dimensional surface. The view that you draw shows the connection between where you (specifically your eyes) are in relationship to the object being drawn. If you move while looking at the object, your view will change. A perspective drawing is like a moment frozen in time, or a snapshot. Thinking of it this way will help you draw the perspective correctly.

Objects that are closer to you will appear bigger, and those that are farther away will appear to be smaller—though in reality they may all be the same size. The technique I will show you in this chapter will help you draw the objects in the front (or foreground) life size, those that are farther back toward the middle ground smaller, and those in the background even smaller.

I find that measuring is crucial to learning and seeing perspective. Many students protest when I ask them to use a ruler for measuring. Using a ruler takes getting used to, but ultimately you will save lots of time because you will catch mistakes early on. The ruler may even become your good friend, helping you capture proportions and perspective in only a few seconds.

# Observing a Cup in Perspective

Circles and ellipses are important in botanical drawing because they can help measure the correct proportions of flowers in perspective. A circle's height and width (its diameter) are equal in size. An ellipse is a circle where one dimension (height or width) is smaller. As such, an ellipse can describe that circle in perspective.

## Procedure:

Hold your cup or mug up so you are looking straight inside it. The outside of the top of the cup should form a circle. Start to tilt the cup away from your eyes. Stop and look at the shape of the outer rim. Note that the width of the cup should still be the same, but the depth of the cup should be smaller and narrower, creating an ellipse. As you tilt the cup even further away from your eyes, the depth should get smaller and smaller. At eye level it should appear as a straight line. The diminished dimension of the original circle is called foreshortening. Any dimension that appears to be smaller as it recedes in space should be foreshortened when you are drawing that object.

### WHAT YOU'LL NEED:

a teacup or mug

*Quercus rubra (red oak acorns)*, 2009, colored pencil on watercolor paper, 8$\frac{1}{2}$ x 11 inches (21.6 x 27.9 cm)
*This acorn has an outer cup-like shell called a cupule. Inside the cupule is a partially enclosed nut.*

These four views of an acorn cap illustrate a cup shape, as found in nature, shown from various angles.

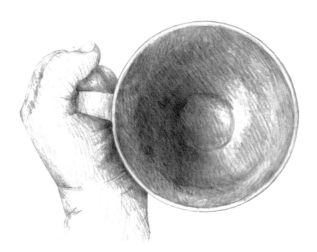

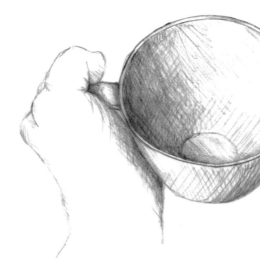

When you hold your cup as shown, the rim forms a circle.

When you hold the cup as shown here and you look at the top rim of the cup, it no longer appears to be a circle because the depth of the cup appears to be diminished.

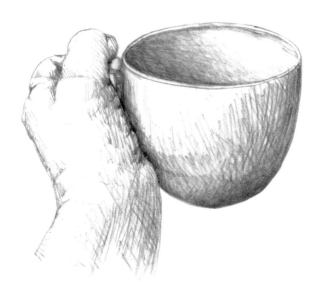

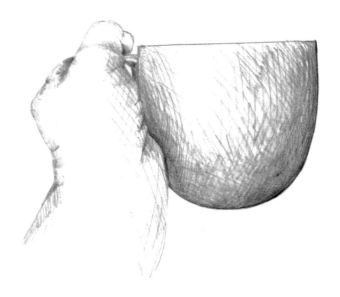

In this view, the depth of the circle is even smaller, creating a definite ellipse.

In this view, you don't see inside the cup at all.

# MEASURING
# IN PERSPECTIVE

Measuring is essential for establishing perspective. This exercise teaches you how to measure using an imaginary window, which is a helpful way to think about how to document the perspective of what you see.

## PROCEDURE:

Position an imaginary window right up next to your tulip, as shown below. (If you like you can use a real piece of Plexiglas for this, but it is not necessary.) If you take all of the measurements of your tulip at the imaged windowpane, your drawing will be both in perspective and also life size. Always draw the components in the front of your drawing life size. Objects farther away in the background will appear smaller on your imaginary window and should be drawn that way. This will help create the illusion of space receding.

To establish a consistent view, try sitting up straight with your back pressed against a chair. Position your flower directly in front of you. Line up your body, your drawing pad, and your flower all in one line. Pretend to seat belt yourself in the chair, especially keeping your shoulders and head stable. Take all your measurements right up against this imaginary window, which is touching your flower. In the next exercise we will practice measuring and drawing a flower, but for the time being just try to understand the concepts presented in this observation lesson.

When I first started teaching perspective I had a beginning student, Trudy, who didn't understand how to measure in perspective. The assignment was to do a still life of green vegetables. She worked extremely hard on rendering her vegetables. Each vegetable was rendered quite well, but they had no relationship to the space in which they were sitting. I was very excited when I saw her work, because it was a fabulous example of what not to do.

I showed Trudy how to set up the vegetables in an overlapping arrangement and how to measure up against the imaginary window to give the illusion of three dimensions. She went home and totally redid the assignment. She did an excellent job. When seen side by side, these drawings clearly explain the benefit of using perspective.

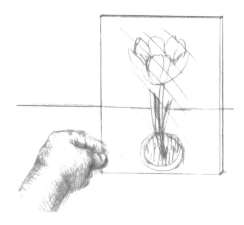

Visualizing an imaginary window can help you understand how to measure the features of your flower.

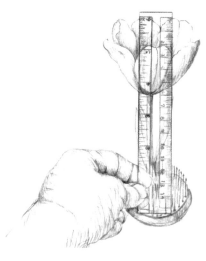

The right way to measure. Position your ruler right next to your flower for measuring on your window.

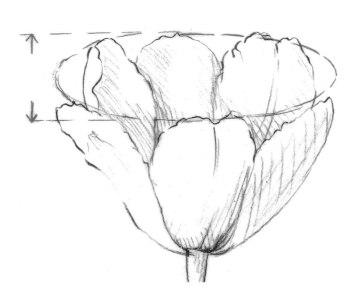

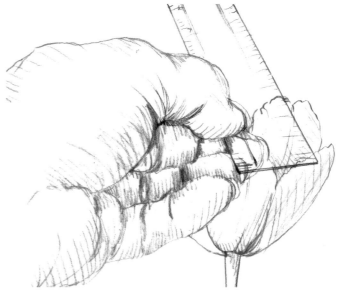

When measuring is done correctly, the illusion of perspective is created. Notice the realistic foreshortening, as exhibited by the elliptical shape of the inside of the tulip.

The wrong way to measure. Measuring "inside the window" will ensure that your objects will not be in perspective.

An example of a student's work, before proper measuring was learned. Notice how these vegetables seem to be floating in space.

The same student's work, after proper measuring was learned. These vegetables seem to be sitting on a table and leaning on each other, creating a realistic composition.

# TURNING A CUP INTO A TULIP

Now we are going to actually draw the perspective of a flower, using the techniques you observed in the previous two exercises.

## PROCEDURE:

Hold your tulip as you did the cup in the exercise on pages 48 to 49, looking right inside of it. The tips of the petals should follow an imaginary outline of a circle. Then tilt the flower away from your eyes. As you do this, the circle will turn into an ellipse. Once you have found the ellipse, stop; this will be the perspective that you will render in both of the following two drawings. Place your flower in a frog prong so you can clearly see this view.

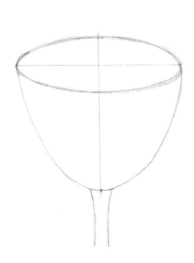

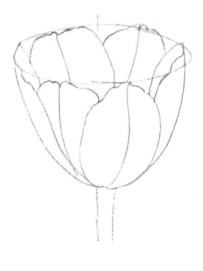

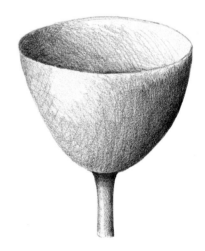

Draw the outline of a cup with the dimensions of your tulip in perspective. The height and width of the cup in your drawing should match the height and width of your actual tulip in perspective.

Using the dimensions and orientation of your first drawing as a guide, create a second drawing—adding petals to the basic form to turn your cup into a tulip. Draw each petal radiating out of the stem of the tulip.

Return to your first drawing and tone your cup shape. You might want to refer to pages 32 to 33 to jog your memory about how light hits this form. Pay close attention to the juncture of the inside and the outside of the cup. This is an opportunity to show dramatic contrast in values.

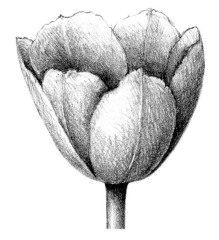

## — RENDERING —
## ALTERNATE VIEWS OF THE TULIP

Refer again to the exercise on pages 48 to 49. Notice how the second view shows a fair portion of the cup's interior. So, too, with a flower.

When a tulip is viewed from a more pronounced angle than the one in this exercise, two things occur: The height of the ellipse formed by the tip of the petals becomes larger and the reproductive parts become visible. These features will be discussed in greater detail in chapter 9.

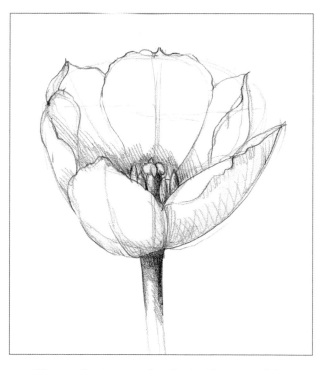

The reproductive parts of a tulip sit right on top of the center axis.

Return to your tulip drawing. Using the drawing you made in Step 3 as a guide, tone the individual petals of your tulip. Be sure to show which petals are in front and which are behind by adding a bit of value behind the petal in front. (More on this later!)

# Drawing Three Views of a Daisy

Daisies appear to be simple flowers, but actually they are extremely complex—both in terms of their botany and their structure. Let's examine a single daisy now—from three different angles. In later chapters we will study the daisy in greater detail.

## Procedure:

This exercise is not intended to get you to focus on rendering details yet but just to help you understand the perspective of the daisy and how circles and ellipses can be used to draw the daisy. The exact number of petals is not important, as the number of petals on similar daisies will vary.

### A Circular, or Straight-On, View

Cut one daisy and remove the stem so that it lies flat and is easy to observe. Look right into the center of the daisy. This is a straight-on view. Measure the key components of the flower.

Using your graphite pencil, very lightly mark the height and width of the outer circumference of the flower. Then sketch the guidelines for the outer dimensions—first as a square and then as a circle. The outer petals of the daisy should fit into this circle, and the center of the daisy will fit into a smaller circle in the middle of the flower.

Now add petals to this circle. Some petals will be on top of others. Draw the top petals first. Each petal radiates out from the center point. First, draw a line to represent the center of each petal; then draw the sides of the petal. Do not worry about rendering precise details; just try to capture the general shapes from this perspective.

### Ellipsis View

This view will be slightly tipped back in space. To help draw this view, you may find it helpful to secure the stem of your daisy in a frog prong inside a low cup or vase filled with water to keep your flower from wilting.

Measure the width of the daisy—from the outer tips of the petals on the right to the outer tips on the left. The measurement should be the same as the width of the daisy in your first drawing. Now measure the height. Be careful not to reach into your picture plane (as shown on page

**WHAT YOU'LL NEED:**

at least two daisies, roughly the same size

a low vase or cup

a frog prong

a graphite pencil

drawing paper

an eraser

a ruler

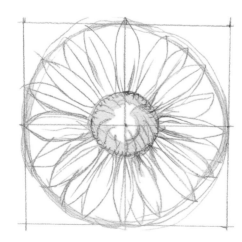

A straight-on view of a daisy fits into a circle.

51). Take the measurement with a squinted eye if it helps (also, do not move your head when you measure). Remember, a consistent view is important.

Now take the height (or depth) measurement again. Measure twice—or even three times. Slight variations in measuring are huge in a flower that is only 2 inches wide. The height should be less than the width. Draw a rectangle, using these dimensions. To help draw an ellipse correctly, divide your rectangle into four equal parts by using a vertical and horizontal straight line in the center. Now draw the ellipse, keeping each quadrant the same size or symmetrical.

Now position the center of the flower. To do this correctly, begin by erasing the center horizontal line. Doing this will help you to not confuse the center of the outer ellipse with the yellow center of the flower. (Note that the yellow center is actually made up of hundreds of tiny flowers, called disk florets.) This is when foreshortening comes into play. The center of the flower should be slightly closer to the front petals. The petals in the front should be shorter than the petals in the back, continuing the illusion. Once you have correctly positioned the central disk, start to add the petals, using the outer edge of the ellipse to determine the length of each petal.

## A Cone-shaped View

Reposition your daisy in the vase so you can see the underside of the front petals and the involucre (the collection of leaflike structures that subtends the flower) at the bottom. You still want to see some of the inside central disk and some of the back petals. The shape of the flower has now changed— the tips of the petals make a narrow ellipse, and you see underneath the daisy as well. The flower is now a modified cone shape. As you can clearly see both the inside and the outside of the flower, this view also enhances the three-dimensional qualities of the daisy.

Measure the width first. It still should be the same as it was in the other two exercises. The height, however, should be quite diminished.

Measure all of the important dimensions. Starting at the bottom of the flower, measure the width of the involucre. Measure from the bottom of the petals in the front to their tips. And finally, measure the yellow center and the back petals. Notice how dimensional the central disk is; it is not a flat structure but rather very spherical. Once you have laid out the dimensions, you can delicately add the individual petals onto the shape, making sure to draw the front petals with a foreshortened view.

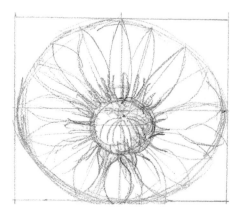

This daisy is tipped back into space. It has become foreshortened and fits into an ellipse.

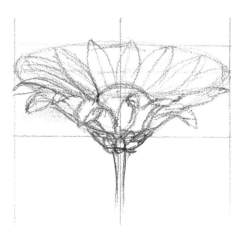

This view shows both the underside and inside of the daisy. The overall shape is a cone.

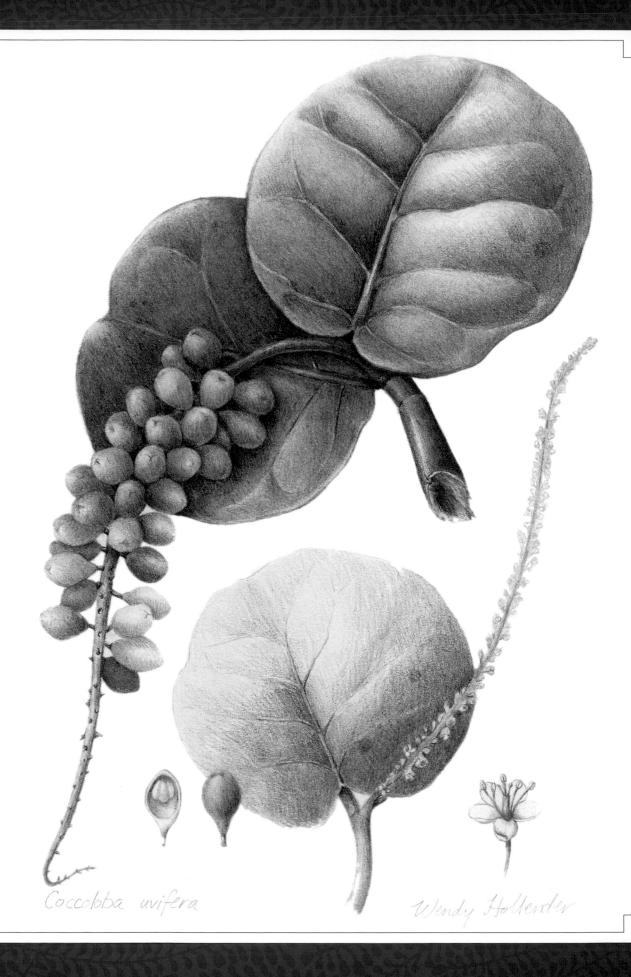

*Coccolobba uvifera*

Wendy Hollender

# Putting Value and Perspective Together

*Tropical Sea Grapes (Coccoloba uvifera),*
*2006, colored pencil on watercolor*
*paper, 12 x 9 inches (30.5 x 22.9 cm)*
*The flowers of tropical sea grapes are tiny.*
*In order to understand and draw their*
*structure I magnified the flowers and drew*
*one enlarged as well as the inflorescene*
*on a stem.*

I t feels magical to add value to a well-drawn flower. Once you have spent the necessary time laying the groundwork for your drawing—first measuring and then rendering your flower in an interesting view—adding value is like adding delicious icing on a plain cake. Take your time, build your value slowly, and enjoy the dimensional flower that will emerge.

During the course of this chapter you will learn to break down the process of drawing and toning a flower into a predictable six-step procedure. This is helpful because flowers are incredibly complex and difficult to draw. Their petals are so thin, often rippling in different directions. In addition, flowers feature many overlapping elements that need to be clearly defined.

You will be spending time examining your flower closely, understanding its structure and botany as you go. To tell your flower's story, you will need to understand its structure and function from head to toe. A flower's beauty is tantalizing. After all, its main purpose in life is to attract a pollinator and reproduce. Capturing these qualities takes time and patience, but the rewards are spectacular. Many flowers only live for a day, but your drawing will last for a very long time.

# DRAWING A CAMPANULA IN BLOOM

The campanula is a cup-shaped flower with a fused corolla—though the petals separate slightly at the top. This makes for a good first model in drawing a simple flower. This exercise allows you to practice putting toning and perspective together in a pencil drawing. It is also the first exercise to introduce the Six-Step Technique for Rendering a Flower.

## PROCEDURE:

Set up your specimen in a pleasing manner and then follow the procedure outlined below.

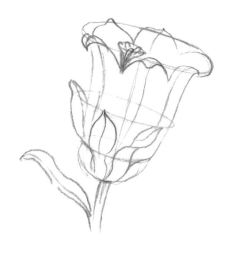

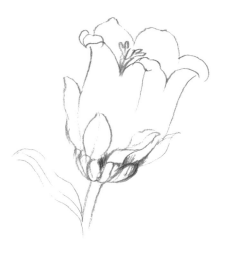

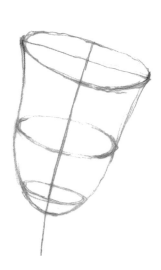

Find and draw the center axis. (All petals, sepals, and reproductive parts radiate out from this center axis, so it is helpful to learn to use it.) Look for any simple geometric shapes, and lightly rough them in. The top ellipse measures the tips of the petals, the middle ellipse measures the tips of the sepals, and the bottom ellipse measures the bottom of the sepal cup.

Add the petals onto the cup shape—first by drawing the center line of each petal as it radiates from the center axis, and second by articulating the edges of each petal as they separate from the cup shape. Add in sepals and reproductive parts that are visible.

Erase your measuring lines and draw the finer details and subtleties of the edges of the petals. If something is not correctly drawn, go back and check your measurement!

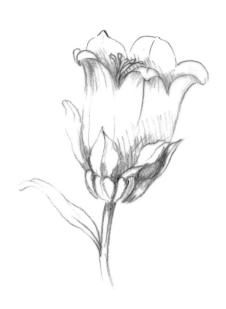

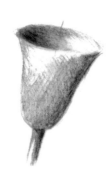

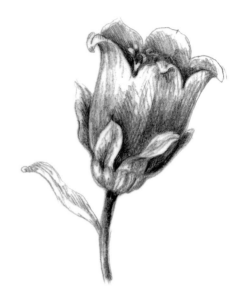

Start toning the overlapping forms, including the petals, sepals, and reproductive parts. It is important to delineate what is in front and what is behind by adding a bit of tone on the areas in back.

Now make a thumbnail sketch that articulates the overall shape of the flower, and tone the shape as though the light were coming from the upper left. Use either a real source of light or imagine the source.

Referring to your thumbnail sketch, tone the whole flower. Closely observe your real flower as you draw, noting the subtle differences in the surface and details. Use your imaginary light source for toning.

— DRAWING A PROPER ELLIPSE —

Sketching an ellipse correctly is more complicated than it may seem. First, draw vertical and horizontal lines, indicating the height and width respectively. (You can enclose these measurements in a rectangle, if you desire.) Next, draw a curved edge on each of the four endpoints on these two lines to start your ellipse. Then, connect each curved edge gradually and gracefully to create a smooth elliptical shape. Each quadrant should be symmetrical. Avoid creating pointed edges, as these will generate a diamond shape, not an ellipse.

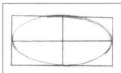

To start your ellipse, draw a curved edge on each of the four endpoints. Then connect each curved edge gradually and gracefully, creating a smooth elliptical shape.

# DRAWING A LILY IN BLOOM

This exercise will help you complete the skills you need to master the Six-Step Technique for Rendering a Flower.

## PROCEDURE:

Set up your specimen in a pleasing manner, and then follow the procedure outlined below.

**WHAT YOU'LL NEED:**

a blooming lily*

a low vase or cup

a frog prong

a graphite pencil

drawing paper

an eraser

a ruler

*If you don't have access to a lily, you could use another cone-shaped flower (such as an amaryllis or cala lily) instead.

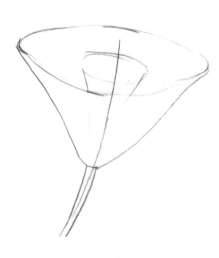

Always draw the center axis of your flower first. Identify the geometric shapes closest to your flower and lightly rough them in. In the case of a lily, it will be two nestled cone shapes, both of which follow the center axis. The second, smaller cone contains the reproductive parts of the flower.

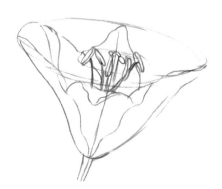

Add the petals onto the cone shape—first by drawing the center line of each petal as it radiates from the center axis, and second by articulating the edges of each petal. (Notice on a lily how some of the petals often turn.) Then add the reproductive parts.

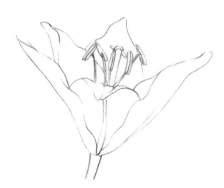

Erase your measuring lines and draw the finer details and subtleties of the petals and other parts of the flower. Notice that lilies have a strong center vein in each petal.

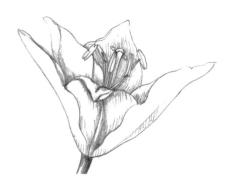

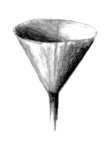

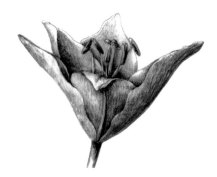

Now make a thumbnail sketch of the overall cone shape, as if the light source were coming from the upper left. Use either a real source of light or imagine it.

Start toning the overlapping forms, such as the petals. Some of the petals curve inward and over, which is an added challenge. The center veins on each petal are prominent and can be toned like a cylinder.

Referring to your thumbnail sketch, tone the flower. The prominent anthers can each be toned like a cylinder. Be sure to emphasize the overlapping areas of the turning petals.

## — EXAMINING —
## THE REPRODUCTIVE PARTS

The reproductive parts of the lily fit into a small cone shape. Knowing this is essential for measuring accurately and giving the illusion of three dimensions with this specimen. Notice how the pistil follows the center axis of the lily.

When you buy a lily from a florist, the anthers often have been removed, as the deep rust-colored pollen in them stains easily. If your anthers have been removed, you can open a lily bud, often on the same stem, to see the developing anthers and add them to your open flower.

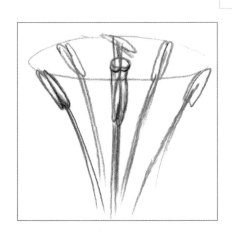

The tips of the stamens form an ellipse.

# RENDERING A FORESHORTENED DAFFODIL

A daffodil combines a modified cup shape with an outer ellipse shape. Therefore, capturing a three-quarter view of this flower requires being able to render both shapes simultaneously in a foreshortened manner.

## PROCEDURE:

Set up your daffodil, being careful to turn it so that you are neither looking at the flower straight on nor looking at its "profile." Now follow the Six-Step Technique for Rendering a Flower.

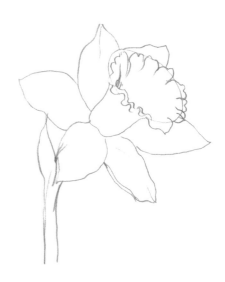

*1*

Establish the basic forms in perspective. To do this, first draw the center axis of the daffodil. Next, draw the cup shape, known as the corona. Then draw an ellipse as a guide to where the outer petals will be.

*2*

Add the petals, by first drawing the center line of each petal and then by articulating the outline of each petal. Notice how the petals radiate from the center like spokes radiate from a bicycle wheel. Erase the outline of the outer ellipse.

*3*

Refine your drawing, adding the ruffled corona. Draw the delicate contours of the outer petals. Erase the center axes—both of the flower and of the individual petals.

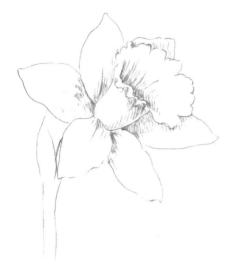

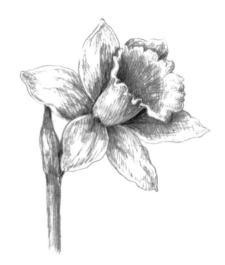

4 Once you have drawn the entire flower, it is time to start thinking about the overlapping areas. Add a bit of tone behind them to bring the front elements to the foreground.

5 Make a thumbnail sketch to help you visualize your light source, paying particular attention to the area that will be in the shadow cast by the tubular corona of the flower.

6 Refine your toning on the daffodil, clearly defining the overlapping elements.

## — THE IMPORTANCE OF PATIENCE —

It takes time to create botanical illustrations. You need to work slowly and methodically, with close observation and slow drawing. It is best to practice each subject presented over and over again—and at first, not to worry about completing finished drawings. As a matter of fact, it is best to try not to worry at all. I am amazed at how often I hear the phrase, "I am afraid. . ." (to ruin my drawing, to mess up my paper, or to make a mistake— whatever it is that causes worry). Understand that learning to draw requires you to do all of the above, many times over. This is part of the process. When you hesitate, remember that this is not rock climbing. Making mistakes is part of how you learn. The good news is that the process is fun, you will learn an incredible amount about the plants you are studying, and, as mentioned before, it may feel at times like you are very relaxed and meditating. I think you will also enjoy looking back on your pages in your sketchbooks to see the progress you have made. So try not to worry too much, and instead take pleasure in learning from your mistakes.

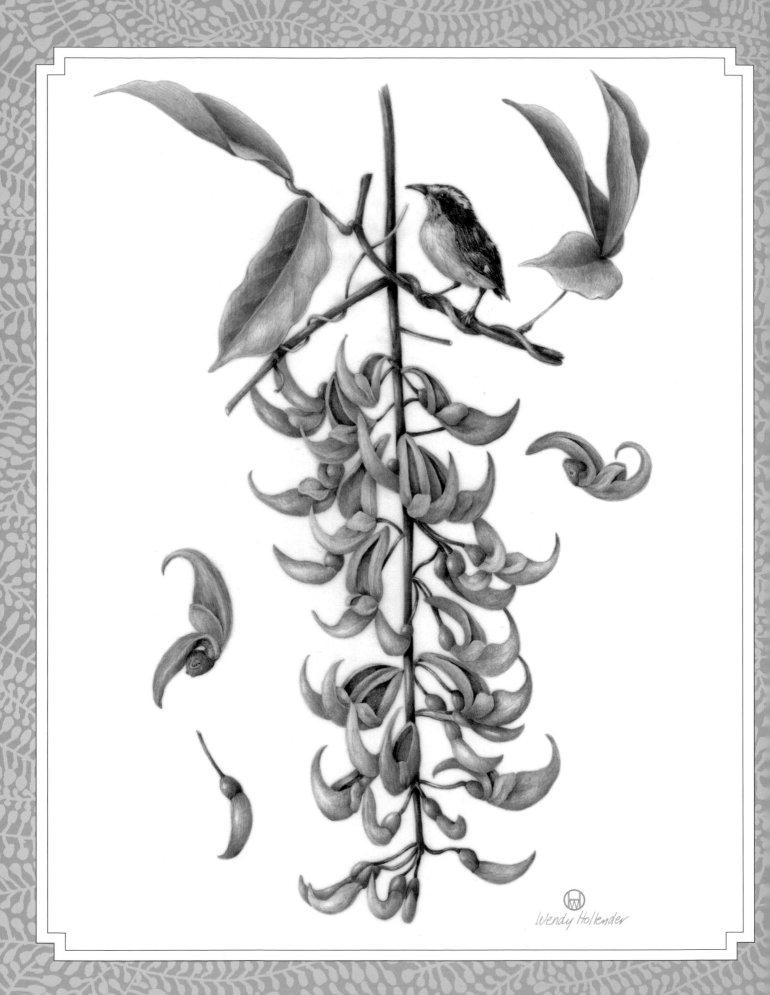

Wendy Hollender

# UNDERSTANDING COLOR

*Jade Vine with Bananaquit (Strongylodon macrobotrys and Coereba flaveola), 2009, colored pencil and gouache on matte film, 18 x 12 inches (45.7 x 30.5 cm)*
*Believe it or not, these jade vine flowers are truly bright turquoise. Very few flowers in nature are this hue. This vine grows on the terrace of the ASA Wright Nature Preserve in Trinidad and makes for an excellent lesson in learning how to mix color.*

The earlier chapters featured some simple color exercises, but now we are going to focus exclusively on color and its place in drawing. Color theory is best understood by hands-on use of your colored pencils. Concepts that may be challenging in the abstract can quickly be grasped if you do some color mixing on your own, following the guidelines I introduce in this chapter.

Color can be used in pencil drawing in three ways: First, as a way of adding value to form, whereby enhancing the three-dimensional quality of your image. Second, as a means of conveying nature's true palette, which is helpful in identifying plant species. Third, as a practical tool for achieving color harmony in a composition.

The ability to identify colors in nature and then to mix these colors to create an accurate representation is one of the main objectives of botanical illustration. To achieve this goal, we will first focus on identifying colors we see in our botanical specimens; then we will create "recipes" for mixing these colors; and finally, we will discuss color harmony and color combinations. So read on—you'll learn about color and you'll have fun!

## BASIC COLOR THEORY

There are three primary colors: yellow, red, and blue. These colors cannot be made from mixing any other colors together. When the primary colors are combined in pairs, they create the three secondary colors: orange, violet, and green. (Mixing equal parts of yellow and red creates orange; mixing equal parts of blue and yellow creates green; mixing equal parts of red and blue creates violet.) When a secondary color is mixed with one of its adjacent primary colors, it creates a tertiary color. There are six tertiary colors: yellow-orange, red-orange, red-violet, blue-violet, blue-green, and yellow-green.

Color wheels have been a tool for both scientists and artists ever since the first color wheel was developed by Sir Isaac Newton in the late 1600s. Color wheels visually explain color theory. They show how mixing colors creates new colors and how these colors relate to each other. They can also be used as a guide for mixing color.

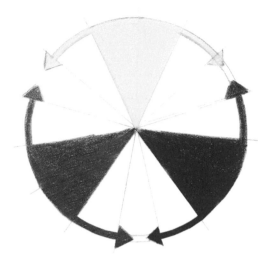

The three primary colors: yellow, red, and blue.

## TERMS USED IN COLOR THEORY

Here is a list of some important color terms that we will use:

HUE (also known as local color) refers to the common names we give to colors, such as yellow, blue, or green. An apple can be of a red hue, a green hue, a yellow hue, and so forth.

VALUE (also known as tone or tonality) is the lightness or darkness of a color. Examples are dark red or light green—wherever there is a gradation of shading. In rendering three-dimensional forms, value is critical.

INTENSITY (also known as chroma) refers to the brightness or dullness of a color. A bright red poppy flower or a dull brown nut are respective examples. Intensity can also refer to the level of saturation or richness of color as opposed to a light wash or tint of color. Bright and dull colors are used

to create the illusion of depth in painting and drawing, by making colors appear to advance or recede in space, respectively. Likewise, warm and light colors tend to advance, while cool and dark colors tend to recede.

COMPLEMENTARY COLORS complete each other. This refers to the fact that any two complementary colors are made from the three primary colors. In other words, red (a primary) is the complement of green (which is made from yellow and blue, the other two primaries). Complementary colors are opposite each other on a color wheel. When two complementary colors are next to each other in a composition they can be very intense and appear to vibrate. When mixed they become a muddy gray or brown. The complement of a color can be added in small amounts to that color to dull or darken it, as when you want to create a shadow.

# CREATING A COLOR WHEEL IN TWELVE HUES

Making a color wheel will help you blend colors to create new colors and visualize the ingredients in each color blend.

## PROCEDURE:

Almost everyone has made a color wheel at some point in his or her life—and for me this is always fun to do. Use a template or compass to make a circle about 6 inches in diameter.

Divide your circle into twelve equal segments. If you have one on hand, you can use a protractor to measure each segment at 30 degrees. Alternatively, you can divide your circle into three equal segments (eyeballing the divisions at the twelve, four, and eight o'clock positions) and then divide each segment in half and then in half again. The segments don't have to be perfect.

Once your circle is divided, make a smaller, concentric circle inside of the larger one. Using your ruler, articulate the edges of your twelve segments. Now, starting with yellow, fill in the segments one by one to create your own twelve-hue color wheel. Ten of the segments will be pure colors. But two colors will be blends: yellow-orange is a blend of cadmium yellow #107 and dark cadmium orange #115; red-orange is a blend of dark cadmium orange #115 and pale geranium lake #121.

### WHAT YOU'LL NEED:

a graphite pencil

a cadmium yellow #107 pencil

a dark cadmium orange #115 pencil

a pale geranium lake #121 pencil

a middle purple pink #125 pencil

a purple violet #136 pencil

an ultramarine #120 pencil

a cobalt turquoise #153 pencil

a permanent green olive #167 pencil

an earth green yellowish #168 pencil

a cadmium yellow lemon #205 pencil

watercolor paper

an eraser

a template or compass

a protractor (optional)

a ruler

### NOTE:

If you make the exercises listed in this chapter in a spiral pad, it will become your own color reference book.

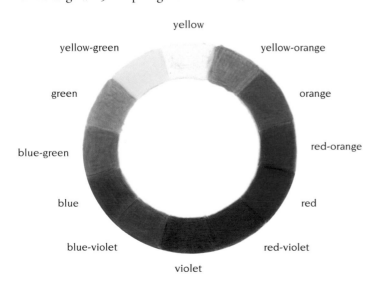

yellow

yellow-green · yellow-orange

green · orange

blue-green · red-orange

blue · red

blue-violet · red-violet

violet

This color wheel shows the twelve hues. Some are the colors of the pencils used, and some are blends made by combining colors, as described above.

# Color Bias Theory

In the reality of color mixing, there are no true primary colors. In pigments there are reds, blues, and yellows, and each individual color has a bias toward another (secondary) color. In other words, a red can appear to be more orange or more violet. As such, it can appear to be warmer or cooler. In using color bias theory, each primary color can be thought of as two colors. This concept becomes very helpful when mixing colors.

For this reason, in the choices I have made for my color palette of pencils (see pages 18 to 19), I include two yellows, two reds, and two blues. It is important to understand color bias, because brightness is lost when you mix colors with biases in different directions on the wheel. Alternatively, brightness is gained when you mix colors with biases that point in the same direction.

When I first was introduced to the concept of color bias, I found it confusing and eye opening at the same time. It explained why mixing a red and blue together sometimes created a color closer to brown than to violet. Color bias theory explains these situations. It is also tremendously helpful when attempting to create a particular color such as turquoise—a blue-green hue similar to the color that I used to create the image of the jade vine with bananaquit featured on page 64. This theory takes getting used to, but with a bit of practice you will gain a deeper understanding of color mixing and be able to make better-educated choices when choosing colors to blend together.

## Bright, Clear Colors

Mixing two primary colors that point in the same direction (i.e., have the same bias) on the color wheel creates a bright, clear color. For instance, pale geranium lake #121 is a red with a bias toward orange. Cadmium yellow #107, a yellow, is also biased toward orange. Both colors are warm-biased hues. When these two colors are mixed, they will produce a bright, clear orange in the red-orange family.

## Mid-Intensity Colors

Mixing two primary colors that point in opposite directions on the color wheel creates a mid-intensity color. For instance, middle purple pink #125 is a red with a bias toward violet. Cadmium yellow #107, a yellow, is biased toward orange. One color is cool biased, and the other warm. Combining the two produces an orange in between bright and dull.

## Dull, Muddy Colors

Mixing two primary colors that point away from the color on the color wheel that you are trying to achieve creates a dull, muddy color. For instance, middle purple pink #125 is a red with a bias toward violet and cadmium yellow lemon #205, a yellow, is biased toward green. Neither color points toward orange, so mixing them will produce a dull, muddy orange. (Note: A dull, muddy orange is still a beautiful color. This is not a negative judgment, simply a description of the color's intensity.)

From left to right:
(1) cadmium yellow lemon #205 is a yellow with a bias toward green; (2) cadmium yellow #107 is a yellow with a bias toward orange; (3) pale geranium lake #121 is a red with a bias toward orange; (4) middle purple pink #125 is a red with a bias toward violet; (5) ultramarine #120 is a blue with a bias toward violet; and (6) cobalt turquoise #153 is a blue with a bias toward green.

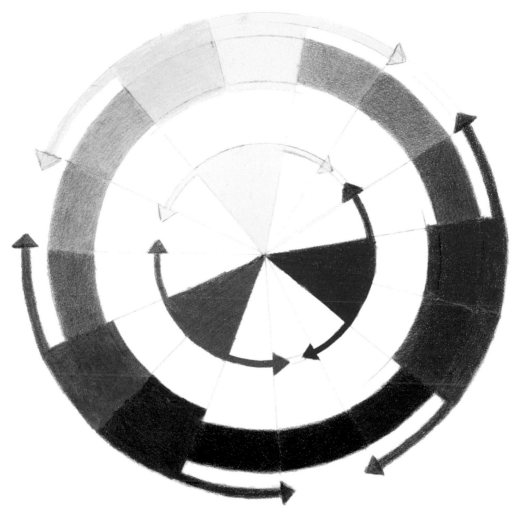

Here is another way of visualizing the two yellows, two reds, and two blues that I have selected for my color palette of pencils. Each colors leans either toward warm or cool.

This color wheel was created using only three primary colors. Notice how dull the violet is. This red (pale geranium late #121) would never be able to create a bright violet.

# CREATING COLOR BIAS BLENDS

Making blends from various combinations of the six primary colors allows you to observe firsthand the differences in the secondary colors created when the biases are similar and when they are different. With just six colors you can create a full range of hues—from bright to dull. This exercise will also help you understand the ingredients in secondary colors.

## PROCEDURE:

Over the years, I have created many versions of color bias blends, trying to convey the concept of color bias theory. Perhaps the most straightforward approach is to create color bars similar to those on page 40. The most important thing is to focus on mixing your colors and noticing what happens.

### WHAT YOU'LL NEED:

a graphite pencil

a cadmium yellow lemon #205 pencil

a cadmium yellow #107 pencil

a pale geranium lake #121 pencil

a middle purple pink #125 pencil

an ultramarine #120 pencil

a cobalt turquoise #153 pencil

watercolor paper

an eraser

a ruler

| Color A | 50/50 blend of A and B | Color B |
|---------|------------------------|---------|

| 75/25 blend of A and B | 25/75 blend of A and B |
|------------------------|------------------------|

a "smoothie" blend of A and B

**1**

Using your graphite pencil, create a series of squares and rectangles as shown. Repeat this process three times so that you have enough guides to make four bias blends on your sheet of paper.

**2**

In the first square, lay down Color A (cadmium yellow lemon #205) to saturation. When laying down one color only, it is okay to press a bit harder and achieve saturation more quickly, as you are not relying on the even mixture of two colors.

**3**

In the third square, lay down Color B (cobalt turquoise #153) to saturation. You may notice that dark colors take longer to saturate than light colors. You can be careful and make beautiful perfectly edged squares, or you can leave your edges rough. Remember to keep layering until you have a nice solid blue square.

In the second square, mix cadmium yellow lemon #205 and cobalt turquoise #153 equally, alternating layers of each color. It may take a total of twelve to twenty layers to achieve saturation, depending on how hard you press. This will result in a secondary color—green. Burnish the swatch by alternating the two colors.

In the fourth square, lay down cadmium yellow lemon #205 and cobalt turquoise #153, but this time use approximately 75 percent of the yellow and only 25 percent of the blue. This will result in a tertiary color—yellow-green.

In the fifth square, lay down cadmium yellow lemon #205 and cobalt turquoise #153, but this time use approximately only 25 percent of the yellow and 75 percent of the blue. This will result in a tertiary color—blue-green.

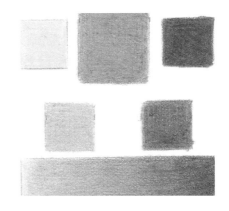

Now create a continuous smooth blend from cadmium yellow lemon #205 to cobalt turquoise #153. I refer to these color blends as "smoothies" because the idea is to create a smooth transition of color the same way we did when creating continuous-value bars on page 40. Lay down cadmium yellow lemon #205 on the left side of the rectangle, gradually getting lighter and fading away toward the right side of the rectangle. Lay down cobalt turquoise #153, starting on the right side of the rectangle and gradually getting lighter toward the left side. As you work, keep alternating between the two colors. The trick is to obtain a smooth, even blend to saturation—with a secondary color in the center of the bar, the tertiary colors on either side of the center, and all of the other, more subtle hues in between.

Carefully observe the result of your single bias blend, featuring cadmium yellow lemon #205 and cobalt turquoise #153.

Repeat this process using cadmium yellow #107 and cobalt turquoise #153 for the second blend, cadmium yellow lemon #205 and ultramarine #120 for the third blend, and cadmium yellow #107 and ultramarine #120 for the last blend.

Notice that the first yellow-blue combination created the brightest, clearest green. This is because both cadmium yellow lemon #205 and cobalt turquoise #153 have a bias toward green. By contrast, notice that the last yellow-blue combination created a dull, muddy green. This is because cadmium yellow #107 has a bias toward orange and ultramarine #120 has a bias toward violet.

Repeat this process two more times, making color bias segments with red-yellow and blue-red combinations, as shown in the two charts below.

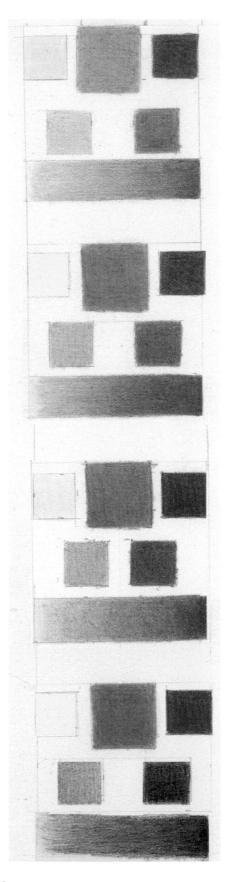

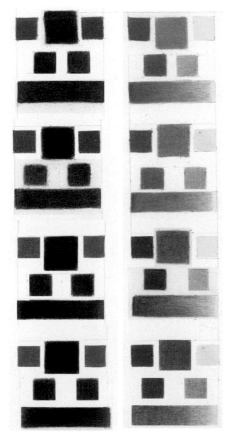

LEFT:
This violet color bias chart features various combination of blue and red.

RIGHT:
This orange color bias chart features various combination of red and yellow.

This green color bias chart features various combination of yellow and blue. The top blend created the brightest, clearest green because both cadmium yellow lemon #205 and cobalt turquoise #153 have a bias toward green.

# CREATING COMPLEMENTARY SMOOTHIES

Understanding complements and how they interact with one another will allow you to create more accurate color renderings. This is particularly useful when you want to dull a color or enhance a shadow.

## PROCEDURE:

Blending two complementary colors creates either a brown or a semi-neutral color, depending on the proportions of the colors that you use. Adding a little of a complement to a color is one way to dull that color.

To start, use a pencil and a ruler to outline three distinct color bands. Each band should be approximately ¹₂ inch high and 2 to 3 inches wide. Allow a generous amount of room in between each of the three bands. The first band will showcase a yellow-purple blend, with untainted cadmium yellow #107 on the left and untainted purple violet #136 on the right. The second band will showcase an orange-blue blend, with untainted dark cadmium orange #115 on the left and untainted ultramarine #120 on the right. The third band will showcase a red-green blend, with untainted pale geranium lake #121 on the left and untainted earth green yellowish #168 on the right.

Create the smoothies exactly the same way as you did in the previous exercise. Notice now, however, that instead of creating a bright blend of hues, you will make dull, muddy colors.

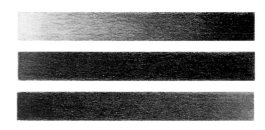

When mixed together, colors that are opposite on the color wheel create brown earth tones.

This color wheel shows how complementary colors (colors that are opposite one another on the color wheel) can be blended to create semi-neutrals and browns.

 # IDENTIFYING THE KEY FEATURES OF A COLOR

The better you train your eye to see the features (hue, value, and intensity) of colors, the easier it will be for you to identify the ingredients of the color. This will allow you to efficiently mix any color that you desire.

## PROCEDURE:

Review the twelve hues commonly used in a color wheel, the values in a typical nine-step value bar, and the range of intensities—all shown to the right. Now take your Venetian Red #190 pencil and locate it on each of the three charts. To do this, first tone a small swatch of the Venetian Red #190 on your watercolor paper and hold this next to your twelve-hue color bar. (It should essentially match red.) Next, put your swatch next to the value bar. (It should essentially match value 6.) Finally, put your pencil next to the chroma bar. (It should essentially match the dull chroma.)

Now try to re-create the Venetian red #170 with your basic twenty colored pencils. Since you identified the hue of as being red, you will base your mixture on pale geranium lake #121. Since the intensity of the color you want is dull, you can use the complement of the hue (earth green yellowish #168) to dull the color. Look at these two pencils next to value 6. They seem close, so you probably won't need to add anything to darken or lighten the value.

Begin by drawing three squares. Color the first square pale geranium lake #121. Color the third one earth green yellowish #168. In the middle square layer the two colors until you are close to the Venetian red #170 color. This is a good way to start to see the colors that make up the ingredients in the blend.

### WHAT YOU'LL NEED:

a graphite pencil

a Venetian red #170 pencil

a pale geranium lake #121 pencil

an earth green yellowish #168 pencil

watercolor paper

an eraser

a ruler

### NOTE:

Try this exercise with a few more colors, including a dark color and a light color. For very dark colors you may add some dark sepia #175. For light colors you can add ivory #103 or white #101. Be careful with white. It will make your colors appear cooler than you may have intended, which is why I tend to use ivory #103 more often than white for light values.

Venetian red #170 is a red hue, value 6, and dull intensity.

These three squares show pale geranium lake #121 (left), earth green yellowish #168 (right), and a mixture of the two (middle) that simulates the color of a Venetian red #170 pencil.

# COLOR INGREDIENTS

## Hues

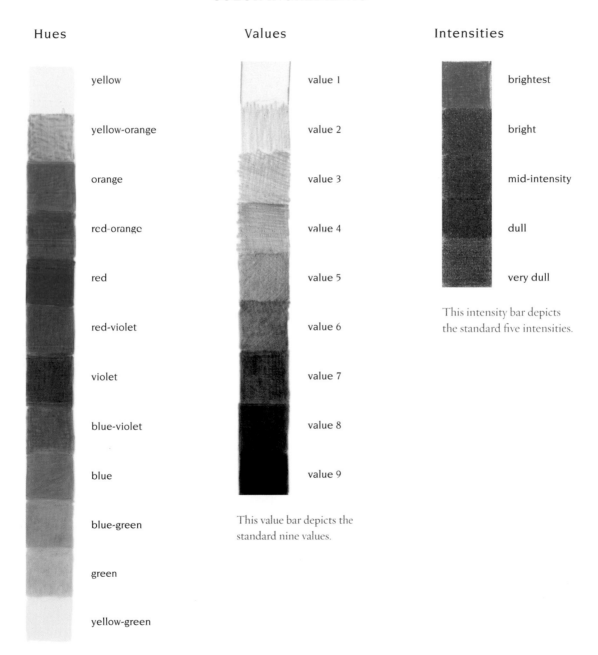

yellow

yellow-orange

orange

red-orange

red

red-violet

violet

blue-violet

blue

blue-green

green

yellow-green

This color bar shows the twelve hues that appear on the standard color wheel.

## Values

value 1

value 2

value 3

value 4

value 5

value 6

value 7

value 8

value 9

This value bar depicts the standard nine values.

## Intensities

brightest

bright

mid-intensity

dull

very dull

This intensity bar depicts the standard five intensities.

# COLOR HARMONY

Once you have mastered the ability to mix any color in nature, you are ready to explore why some colors look harmonious together and others don't. Keep in mind that there is a subjective element to making color choices and that most people have individual color preferences.

During my years as a textile designer I worked endlessly on creating beautiful color combinations. I became very good at matching colors when mixing paint, but that has nothing to do with knowing how harmonious colors will look together. Unfortunately, some of the combinations I chose for my textile designs were less than beautiful, but it was hard to know why.

The first color combination I chose for a floral design often matched the colors of the flowering plant in nature. Those colors usually looked good. For the additional combinations, I would try different colors—with much less success than the original colors. This is because I was arbitrarily choosing combinations of colors. If only I had continued to borrow from nature instead of randomly picking colors, I would have had a foolproof system—because nature is a perfectionist when it comes to the arrangement of color and form. All we have to do is copy nature.

Color can save a drawing that has technical problems, but a beautifully rendered drawing with ugly color will never look good. Color harmony is a pleasing arrangement of colors. As mentioned above, achieving color harmony has a subjective component, but below are a few of the color schemes that artists use. All can achieve successful results.

MONOCHROMATIC COLOR schemes feature one (mono) color (chroma), in all of its light and dark values. Monochromatic drawings vary only in value, not in hue. For instance, a drawing that included red, shades of pink, and white would be considered monochromatic.

ANALOGOUS COLOR schemes feature colors that are next to each other on the color wheel. This approach does not usually include more than two primary colors in a range. For instance, a drawing that included yellow, yellow-orange, orange, red-orange, and red would be considered analogous.

TRIADIC COLOR schemes feature three colors that form a triangle on the color wheel. For example, a drawing that included orange, green, and violet would be considered triadic.

COMPLEMENTARY COLOR schemes feature two colors that are opposite one another on the color wheel. For instance, a drawing that included red and green would be considered complementary.

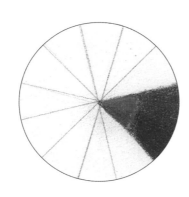

This monochromatic color scheme features various shades of red. Monochromatic combinations are often dull and cold looking. They generally benefit from the introduction of slight variations in hue.

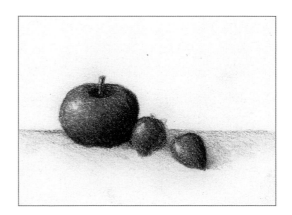

This analogous color scheme features red, red-violet, violet, and blue-violet. I prefer analogous color schemes, such as this one, over other kinds of color schemes.

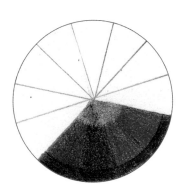

This triadic color scheme features three colors: violet, orange, and green. Triadic schemes pull you in three directions, creating a vibrant but uniform composition.

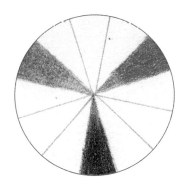

This complementary color scheme features red and green. The colors play against each other, but in a balanced way.

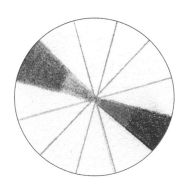

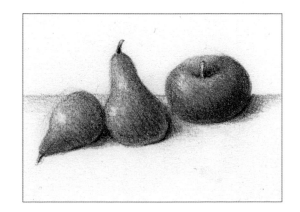

# TONING A WHOLE TULIP IN COLOR

It is time to merge the skills that you've acquired from mastering both the Six-Step Technique for Toning an Image in Color and the Six-Step Technique for Rendering Flowers.

## PROCEDURE:

Review how to measure your flower in perspective (on pages 50 to 51) and the Six-Step Technique for Rendering a Flower (on pages 58 to 63) to help you get ready for this exercise. At last, we are putting all these techniques together to render a flower in color!

Set up your specimen in a pleasing manner, so that the reproductive parts are slightly visible, follow Step One through Step Three as detailed in chapter 6, then proceed as outlined below:

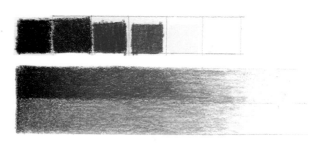

**1** Choose your pencil colors based on the colors of your tulip. (My tulip had a variegated petal pattern going from orange to yellow; therefore, I chose dark sepia #175, red violet #194, pale geranium lake #121, dark cadmium orange #115, cadmium yellow #107, and ivory #103.) Test your colors by making color bars. Then practice rendering your flower by toning the outside and inside of a single petal. During this process I noticed that my tulip had a difference in color from the outside to the inside of the petals. (The outside of the petals was slightly lighter in color due to a protective membrane.) If your specimen is similar, you can carefully peel the membrane off your petal if you like to see this clearly.

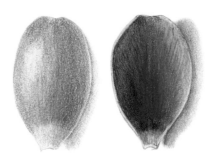

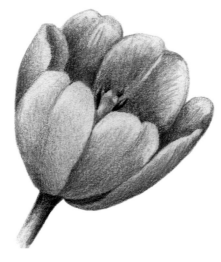

Tone the inside and outside of your flower with dark sepia. Then add color. In my specimen, the tulip's petals turned from orange to yellow, so I blended the orange into the yellow, paying attention to the way the colors merged together.

Continue to apply layers of the local colors over the toned drawing. Use strokes that feather into each other, avoiding harsh transitions of color. Maintain a good range of values, from dark to light. Refer to your live flower to capture the intensity of the colors and the way they blend into each other on your drawing.

Continue layering the colors and then burnish the light areas with your white #101 or ivory #103 pencil. Layer a good range of values to saturation. Clean the edges, add any final details, and finish the burnishing process with Verithin pencils.

## — EXAMINING THE REPRODUCTIVE PARTS IN COLOR —

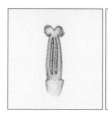

On page 61 we examined the reproductive parts of a lily. Now let's examine the parts of a tulip—this time under magnification and in color. This process reveals not only the intense structure, but bright colors as well. Examining these elements under a microscope helps you to render them with greater precision. This practice will be explored more fully in chapter 9.

The reproductive parts of the tulip seen under the microscope reveal brilliant colors. Drawing them enlarged creates unusual and somewhat mysterious elements that can be added to a composition.

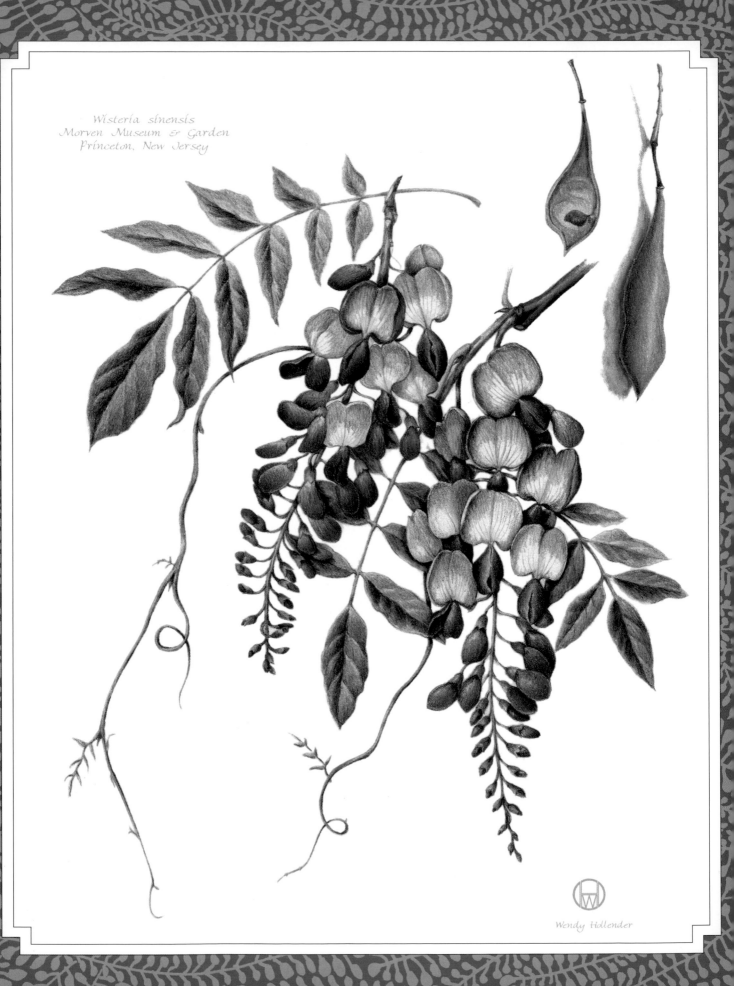

Wisteria sinensis
Morven Museum & Garden
Princeton, New Jersey

Wendy Hollender

# DEPICTING
# OVERLAPPING ELEMENTS
# AND DIFFERENT PLANES

*Chinese Wisteria (Wisteria sinensis),*
2006, colored pencil on
watercolor paper, 16 x 12 inches
(40.6 x 30.5 cm)
*This colored pencil drawing was
commissioned by the Morven Museum
and Garden. They use it consistently on
publications for the museum, invitations,
silk scarves, and limited-edition prints. In
addition, the New York Botanical Garden
used it on their continuing education catalog
in 2007. At the time of this writing, it was
chosen to be printed on cards produced by
Caspari, Inc., a stationery company.*

The ability to understand and draw overlapping planes is crucial to making drawings that appear to be three-dimensional. Once you have mastered drawing and toning one form in color, you can go on to the more complex drawing of combining a few forms together in the same drawing. I like to practice overlapping forms by starting with a small bunch of crabapples, or similar small, rounded fruits or vegetables.

It can be tricky to draw elements that are partially hidden from view, but you can create the illusion of their presence with an understanding of the technique of overlapping. With overlapping, the hidden elements appear to continue—behind what's hiding them! This is essential for an accurate botanical drawing, and there are many exercises to help practice these techniques. It is very satisfying to create overlapping forms, so enjoy—and don't rush—the learning process.

Once you have gained an understanding of creating overlaps successfully, you can take this even further by creating layers of depth in your drawing. You will be able to have elements that appear in the front (closest to you), those that are a little farther back in space, and then elements that appear even farther in the distance. I have emphasized the Chinese wisteria flowers by darkening the leaves behind them.

# Drawing a Bunch of Crabapples

This exercise addresses a common situation found in nature—fruits that appear on several planes. The basic process, however, follows the Six-Step Technique for Toning an Image in Color.

## Procedure:

Place your bunch of fruit in a pleasing arrangement, with the light source coming from the upper-left side.

1

Select your colors and practice blending them. The color of the fruit of my specimen was somewhere between red violet #194 and pale geranium lake #121, so I chose both colors; the stem was earth green yellowish #168. I also selected dark sepia #175 and ivory #103, to shade and tint the colors respectively.

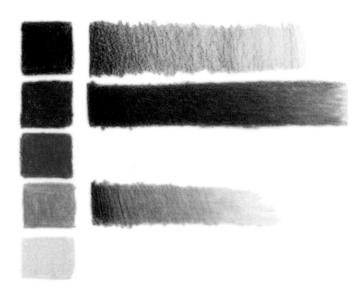

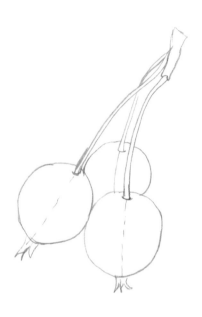

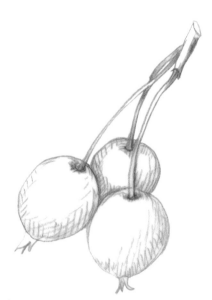

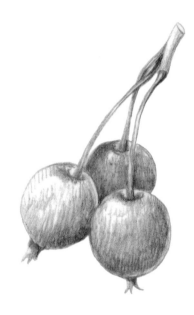

Do an outline drawing of your specimens in graphite pencil, drawing the fruit in front and then adding in those behind it. Your drawing should be life size. If need be, draw the fruit behind completely but lightly where it overlaps and then erase the overlap to ensure your fruit looks complete.

Visualize a light source thumbnail sketch of a sphere. Now begin toning your actual drawing, using dark sepia #175. Define the shapes of the individual pieces of fruit by first adding value to show the overlapping areas. Do this by toning behind the apple in front first.

Continue building values as you would on sphere shapes (as discussed on pages 28 to 29), but consider the overlapping shadows as well. By darkening behind the apple in front, you will make the front apple come forward and create the illusion of space between the apples. Notice how in this cluster there is a reflective highlight on the right side edge of each apple in front.

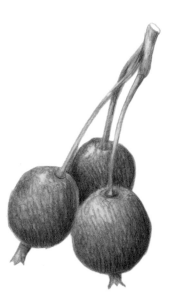

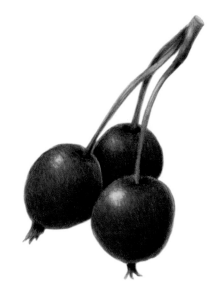

Start to layer in your colors, making sure that the fruit in the front appears to be on top of the other fruit. Once you have added some of the local color, in this case pale geranium lake #121, be sure to add your darker color (red violet #194) in the darker areas, especially in the fruits behind the front fruit. Though you are now working in color, remember to continue rendering a complete range of tones from dark to light.

Finish the drawing in color, following your toning as a guide for layering colors. Intensify colors where needed and burnish with ivory. You will definitely need to go darker in places. The shadow areas behind the fruit in front should start out very dark and then gradually get lighter.

*Crabapples (Malus baccata), 2004,
colored pencil on watercolor paper,
12 x 9 inches (30.5 x 22.9 cm)
In this crabapple drawing, I used numerous
techniques to achieve three-dimensional
effects. For instance, the fruits in various
clusters are in different planes, dried sepals
that appear at the bottom of the fruit
continue along the main axis defined by the
stem, branches appear behind the fruit and
leaves, and the leaves themselves have natural
twists and turns.*

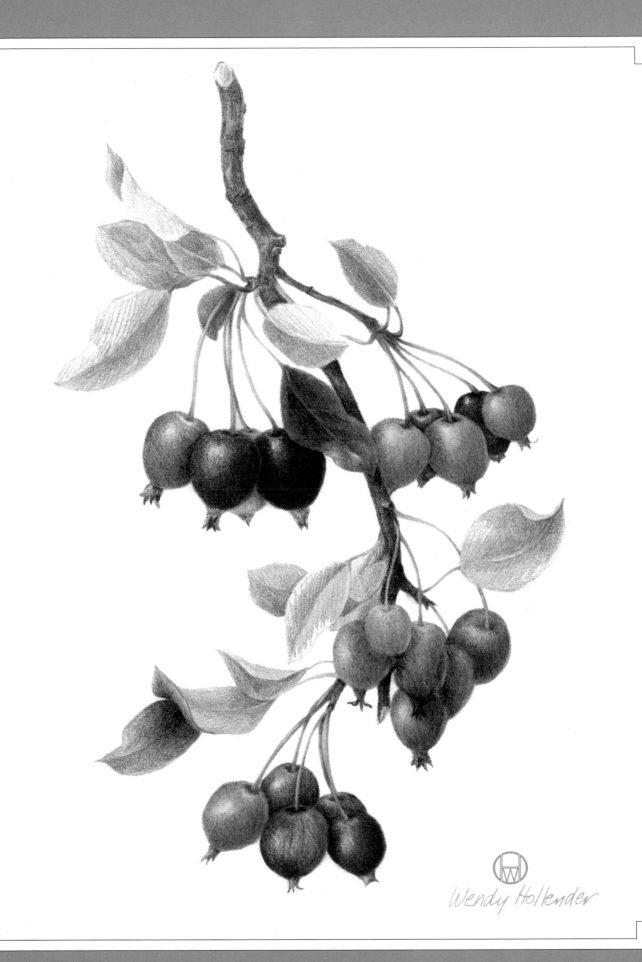

Wendy Hollender

# Drawing a Ribbon That Twists and Turns

A ribbon is an excellent model to use when moving on to more complex forms, such as leaves and petals that twist and bend. This exercise will help you understand how to first draw these overlapping planes and then to add value to make them look three-dimensional.

## Procedure:

Lay your ribbon down on a piece of photocopy paper. Make a couple of pleasing twists in the ribbon, and tape it down to the paper. Next, set up your gooseneck lamp using the consistent, upper-left light source as described in previous exercises.

### WHAT YOU'LL NEED:

a plain grosgrain (or similar) ribbon*

a graphite pencil

watercolor paper

an eraser

a ruler

clear tape

a sheet of photocopy paper

a gooseneck lamp

*The ribbon should be about
½ inch wide by 12 inches long.

*1*

Look at your ribbon closely. For now, concentrate on just one twist. Later you will be able to tackle a more complex series of twists. Identify the side of the twist that is closest to you. Draw a line that copies its curve. Then draw a line that copies the angle of the twisting edge, also known as the width of the ribbon.

*2*

Now draw the other side of the ribbon. Although it disappears behind the front of the ribbon at the twist, draw it lightly as a continuous line that parallels the front edge of the ribbon. This is called "drawing through."

*3*

This step can be confusing, so pay attention! Look at your ribbon again, making note of the front side edge of the ribbon. Add a little value behind the front edge at the overlapping point.

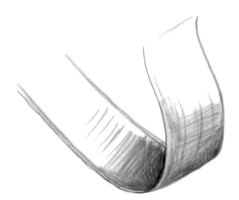

Erase the back line of the ribbon that is hidden from view. The key to creating convincing overlaps is to make sure the edge of the ribbon appears to continue in the proper direction, even though it is hidden. As described above, first "drawing through" and then erasing will help you understand and achieve good overlaps; it is also a way to check your drawing to make sure that all of your lines visually continue.

Now comes the fun part—adding some value to show how the light creates the rolling effect of the ribbon. Remember to use a range of values, with a smooth gradual transition between values. Make sure to leave a light edge on the ribbon; this both simulates the thickness of the ribbon and allows this area to visually come forward.

## — DRAWING THE FULL RIBBON —

Now that you have learned the basic concept of representing overlapping planes, try drawing the full ribbon that you taped down—with all of its twists and turns. For this exercise, you will need a more complete range of colors. (For this example, I used dark sepia #175, middle purple pink #125, and white #101.)

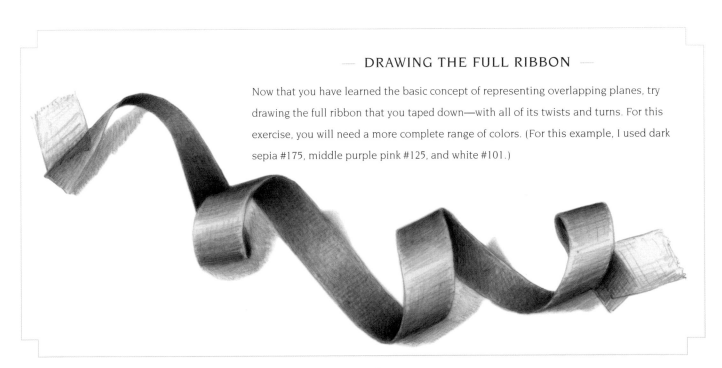

# Drawing a Tulip Leaf

Rendering a tulip leaf is an excellent way to begin to master drawing the twists and overlaps that nearly all leaves demonstrate.

## Procedure:

Look at your leaf, remembering everything you learned in the ribbon exercise above. If your leaf does not hold its shape or is more straight than twisting, you can give it a twist by lightly taping it down to a piece of photocopy paper. If you do this, try to keep a rolling feeling so it will look natural, and be careful to keep it from assuming a crease. Set up your gooseneck lamp to help you see your clear light source.

**WHAT YOU'LL NEED:**

a tulip leaf*

a graphite pencil

a dark sepia #175 pencil

an earth green yellowish #168 pencil

a permanent green olive #167 pencil

an ivory #103 pencil

watercolor paper

photocopy paper (optional)

an eraser

a ruler

a gooseneck lamp

*If you don't have access to a tulip leaf, you can use a leaf from another plant with parallel veining, such as a daffodil, lily, or iris.

Practice drawing your leaf the same way you did the ribbon. Using your graphite pencil, draw the center axis of your stem. With a tulip, the leaf often has a distinct center vein, which is helpful for this drawing. If your specimen has a center vein, draw that (with its twist).

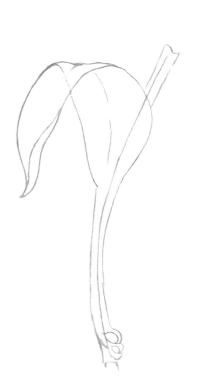

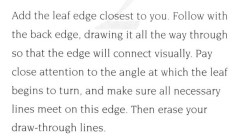

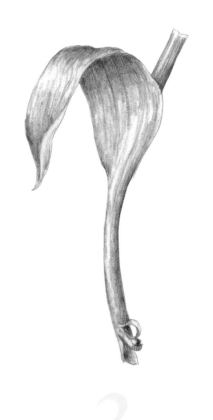

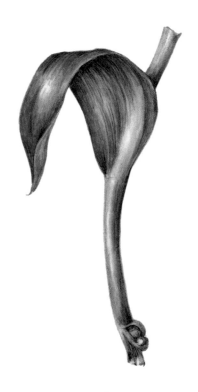

Add the leaf edge closest to you. Follow with the back edge, drawing it all the way through so that the edge will connect visually. Pay close attention to the angle at which the leaf begins to turn, and make sure all necessary lines meet on this edge. Then erase your draw-through lines.

Now tone your leaf and stem with your dark sepia pencil. Tone behind the overlapping areas first, and add in a bit of parallel veining if you see it. Keep the veining subtle, but make your overlapping edges bold by using good contrast.

Using your green pencils, add a range of color to your leaf. (You might refer to page 40 as a reminder of how to achieve a range of values of green.) If you add color and tone in a gradated range, your leaf will look extremely three-dimensional.

# The Characteristics of a Leaf with Net Venation

It is fairly simple to understand the surface contour of a leaf with parallel veining. As we learned in the previous exercise, the process of drawing a tulip leaf is simplified by thinking of a ribbon that twists and turns. But the process gets more complicated when rendering leaves that have a strong center vein and net veining, including the leaves of roses, deciduous trees (such as maples, oaks, and birch), and vines (such as wisteria and poison ivy).

## Leaves

I use the term *plane* to describe a flat surface. Leaves with a mid vein usually have two major planes—one on either side of the prominent mid vein. (Though a paralleled veined leaf such as a tulip may have a mid vein, it is usually not raised and distinct the way the mid vein is on a net-veined leaf.) Light will hit these two planes differently. By showing this, you can create a feeling of dimension to a leaf that might otherwise seem completely flat.

Let us take a close look at the different major planes of this kind of leaf. Imagine an open book. Each of the two facing pages represents a side of a leaf with net veining. This is, of course, a slight exaggeration, but it is helpful in understanding how to tone a leaf to help it look more three-dimensional. The formula for how the light falls on the leaf would look something like the images below.

Along the inside length of the front of the leaf, the two planes often come together at the mid vein, creating a V formation. When a single light source, positioned in the upper left, is used, the right side of the leaf will get more light than the left side, which will be in shadow. The darkest part of the leaf is on the left side, immediately next to the mid vein. This side of the leaf gets a little lighter as it moves toward the outer edge.

The back (or cover) of the book is different. With the same light source, the mid vein can be toned liked a cylinder. Because the mid vein itself is raised it creates a cast shadow immediately next to it on the right. The right side of the leaf tilts downward a bit, creating a dark area. The left side of the leaf is darkest at its left outer edge and gets slighter lighter as it approaches the mid vein.

1  2  3  4

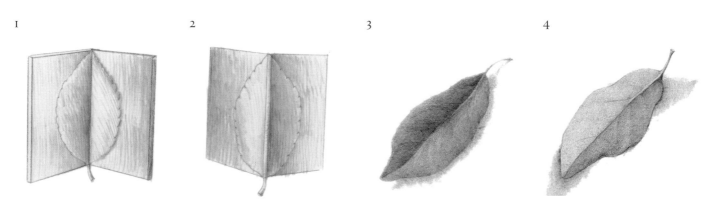

From left to right:
(1) An open book displays two pages, each of which is a different plane. When the upper-left light source is used, light hits these two planes differently. (2) Likewise, the two planes of the cover of a book catch the light in a unique manner, particularly near the articulated nooks of the spine (akin to the prominent mid vein of this particular specimen). (3) The front of this magnolia leaf has been toned to subtly emphasize its net venation and clearly shows how the light hits the two major planes. (4) Similarly, the toning of the back of this magnolia leaf enhances its net venation and the light on its two planes.

Not all leaves have this surface contour, but digesting this concept—and practicing drawing these kinds of leaves—is a way to get started in understanding planes on a leaf surface. Eventually, you will study each leaf for its surface contour and make adjustments to this formula.

And finally, when rendering leaves with net veining patterns—indeed when rendering any kind of leaf—it is important to also pay close attention to the outer edges. Start by sketching a simple shape of the leaf, but later add in any teeth that are present on the leaf.

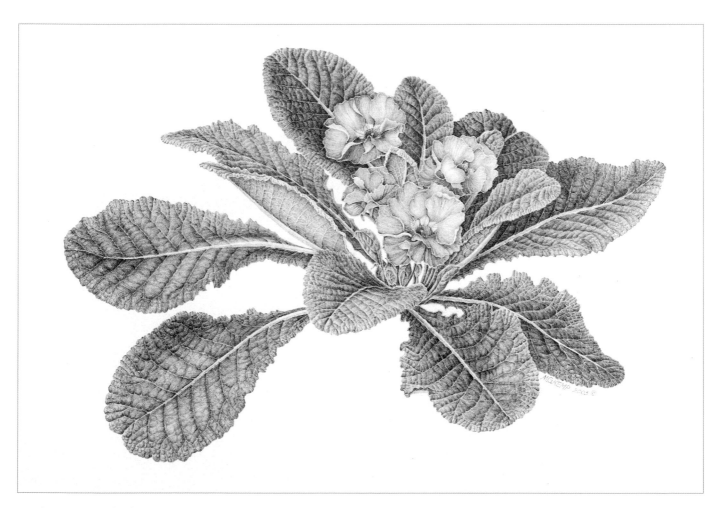

Martha Kemp, *Primula vulgaris,* 2003, graphite pencil on drawing paper. 6 x 9 inches (15.2 x 22.9 cm).
*These leaves by Martha Kemp have distinct net veining patterns—all created with only the use of values.*

## Veins

To understand the venation patterns of a leaf with net veining, it is helpful to examine a large leaf. Even a cabbage or lettuce leaf works well for this!

When I am studying a subject, the first thing I like to do is hold a straightedge or ruler next to the mid vein. This is a good way to see that the mid vein is not straight. Nor, surprisingly, is it curved. It is actually a series of small, straight lines that move in a slightly different direction every time a secondary vein is connected. The secondary vein pulls in the mid vein slightly toward itself.

Likewise, secondary veins are not straight; rather, they vary in the same way as the mid vein. In addition, secondary veins are never as thick as a mid vein. All veins start out wider at the base of the leaf and gradually get thinner toward the end

at the point of the leaf. Secondary veins often branch off, following the outer edge of the leaf rather than continuing straight to the outer edge. The angle that the secondary veins form with the mid vein is important to look at and copy precisely. Likewise for tertiary veins (and beyond), if your specimen has them.

Often, "less is more" when drawing veins. Sometimes a subtle indication of the veining pattern is enough. But if you plan on showing all the details in a leaf's veining pattern, it should be accurate. Otherwise keep the veining subtle and close in color. Some botanical artists, such as Jean Emmons and Martha Kemp, show every minute detail of veining patterns. Others prefer to suggest the mid vein and secondary veins and leave it at that. Both interpretations are acceptable.

LEFT:
Jean Emmons, *Acer sp., Maple Leaf,* 2004, watercolor on bristol board, 13 x 12 inches (33 x 30.5 cm). *This leaf by Jean Emmons has palmate veining. The rendering is so precise, it tricks the viewer into thinking it is real.*

Mid veins on a leaf are not straight or curved, as shown on the left and middle drawings. Rather, as shown on the right, mid veins are a series of lines that change direction slightly at the juncture with secondary veins.

## Stems

The arrangement of the leaves on a stem identifies and differentiates species. The idea is to show clearly three things: how and where leaves are connected to the stem, the shape of the stem, and the variation of the thickness of the stem.

Sometimes two leaves appear on either side of the same point (node) on a stem. This arrangement is called opposite. Other times leaves grow on one side of a stem and then the other (one at each point on the stem). This arrangement is called alternate. Other patterns of leaf arrangement include whorled (when three or more leaves appear at each point on the stem) or rosulate (when leaves are arranged in a cluster around the base of the stem).

Showing the overlapping of leaves and stems adds dimension and realism to your drawings. There are two acceptable ways to do this. One way is to push forward the element in front—in the second example below, a leaf—by darkening the stem behind it. The other way is to keep the background element (the stem) lighter and put more definition on the edges of the top element (the leaf). A third, and unacceptable, way is to leave a light, empty edge between the two overlapping elements. (I frequently see students do this, and it is one of my pet peeves as an instructor.) This creates exactly the wrong emphasis, because just when you need the contrast of dark next to light, you are instead introducing light where there should be dark. This is confusing because light comes forward. Don't be afraid to work next to your overlapping edges. They are one of the most exciting parts in a drawing.

An outline drawing of a stem behind a leaf. The arrangement of the leaves is alternate. Notice how the stem, similar to veins, is not straight but instead changes direction slightly each time a leaf appears.

Adding tone behind the leaf helps create the illusion that the leaf is in front of the stem.

Another way to create a sense of depth is to darken the outer edges of the leaves, making them distinct from the stem. I find this solution less successful than the previous one, unless you are conveying the appearance of a lot of space between your leaf and the stem.

This (unsuccessful) approach to toning a leaf and stem is common among beginning-level students. Notice the light empty area between the leaf and the stem. It creates a halo that comes forward visually.

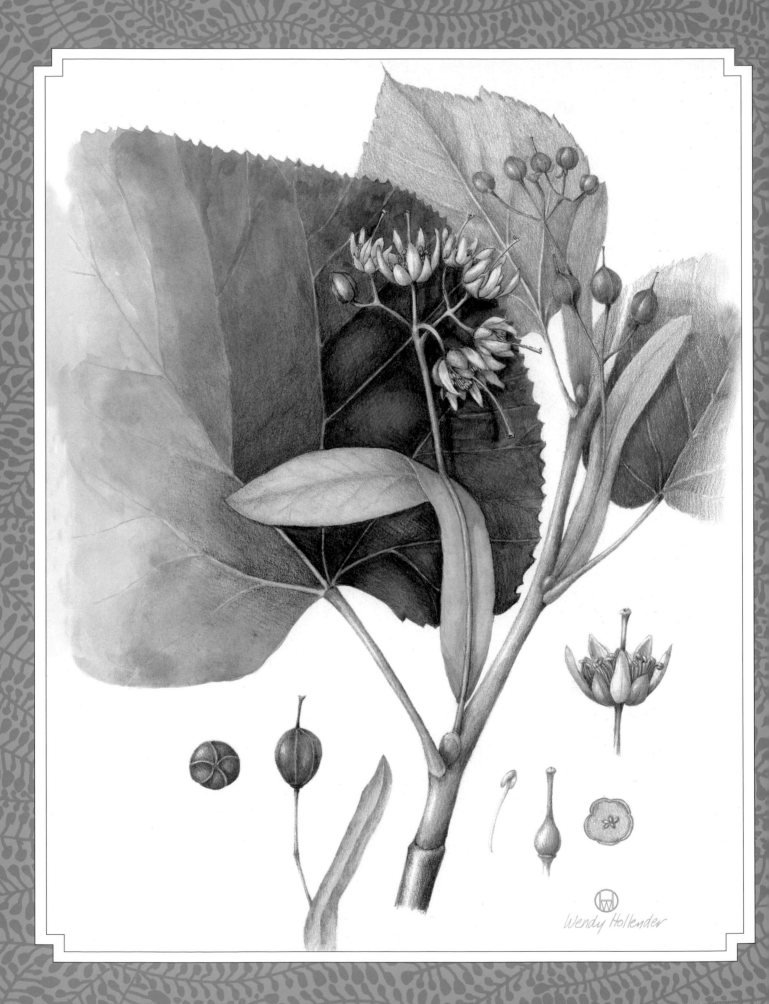

Wendy Hollender

# Understanding the Form and Function of Plants

*Linden Tree (Tilia americana),*
2005, watercolor and colored pencil
on watercolor paper, 16 x 12 inches
(40.6 x 30.5 cm)
*The tiny flowers of the linden tree are hard to
see, but they have a wonderful scent in early
June. Perhaps they smell so intoxicating to
attract pollinators who might otherwise miss
them due to their size.*

Understanding the functions of plants, their parts, and their role in nature's cycle of life will enhance your enjoyment and ability to draw them well. Many people take a plant's lifecycle for granted and often do not even realize the connection between a plant's flower and its developed fruit or seedpod. Although we think of flowers as something beautiful, whose purpose is to enhance our environment, in fact, nature has another purpose, much more important—to ensure pollination and seed development, crucial for the plant's survival.

In other words, a flower's primary purpose is to attract a pollinator—in the case of the crabapple shown on the following pages, a bee—to come inside. The bee is attracted to the flower's colors and smell. After the buds develop in the spring, the flower opens and beckons the eagerly awaiting bee. Inside the flower, close to its reproductive parts, is nectar, which the bees drink. While the bee drinks the nectar his legs and body become covered with pollen from the stamens.

Then the bee quickly and methodically moves on to another flower. In so doing, the bee carries that pollen to the stigma of another flower, where it travels down the style to the ovary, fertilizing the ovules. The ovary develops into a mature fruit (in the example on the following page, a crabapple), which will be fully developed by the fall.

Birds and other animals eat the fruit. After the flesh has been digested, the seeds are dispersed and then they germinate in the soil, where a new tree can develop and grow.

All flowering plants develop some sort of fleshy fruit that holds the future generation's seeds. In the case of roses, the fruit is a rose hip. In a plant such as a honeysuckle, it is a berry. Irises and tulips, by contrast, develop seed capsules that dry on the stems. When dry, the seed capsule opens up to disperse the seeds. Some seeds are spread by wind, some by water, and others are dispersed by animals. Nature is quite varied and inventive in the techniques she employs to ensure the survival of plants. And of course there is agriculture. Our cultivation and planting of vegetables and flowers creates many generations of seeds to come. Anyone who has ever

planted a garden and wondered how weeds make their way into the vegetable beds soon realizes how successful nature's way of creating and dispersing of seeds is!

As I draw, I identify strongly with the botanical world. Like an insect, I am attracted to a flower. I see a spot of color in the distance. I need to get closer. I am drawn in by various hues, unusual forms, and intoxicating scents. After choosing a flower, I take it apart, examining its elements under a microscope and begin to take notes and make drawings of details and colors. Only then am I ready to begin a finished drawing or painting.

Throughout this chapter, as you practice along with me, you, too, will find a special place in this magical world—drawing what you see, becoming a part of it.

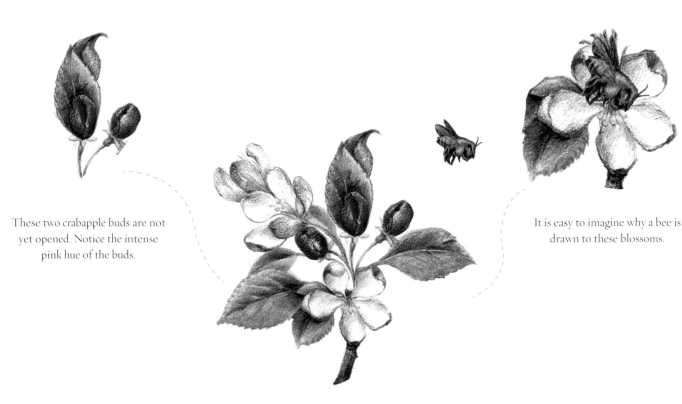

These two crabapple buds are not yet opened. Notice the intense pink hue of the buds.

It is easy to imagine why a bee is drawn to these blossoms.

When the crabapple blossoms open, the petals become almost white—and they smell beautiful!

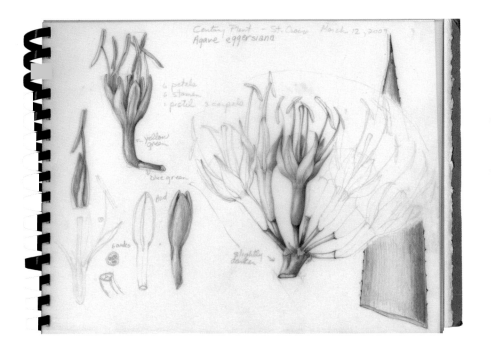

*Century Plant (Agave eggersiana)*, 2009, colored pencil on matte film, 8 ¹⁄₂ x 11 inches (21.6 x 27.9 cm). *I had to work fast to record the information about this century plant. I didn't have time before I left the Virgin Islands to finish the drawing, but I finished it when I returned home.*

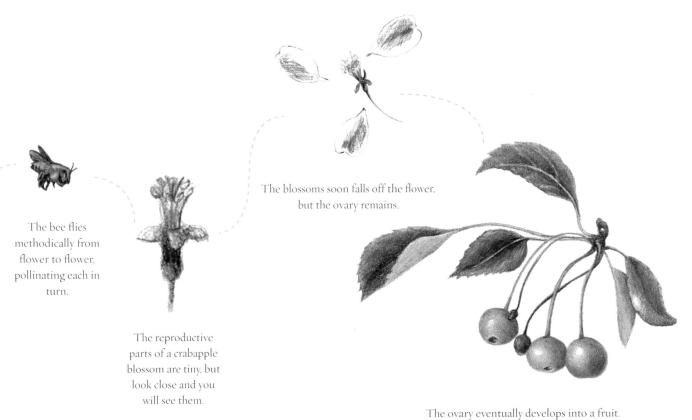

The bee flies methodically from flower to flower, pollinating each in turn.

The reproductive parts of a crabapple blossom are tiny, but look close and you will see them.

The blossoms soon falls off the flower, but the ovary remains.

The ovary eventually develops into a fruit.

# Studying a Tree or Woody Plant Year Round

Recording the lifecycle of a tree for an entire year documents all stages—its developing buds, its blossoming flowers, and its ripening fruit.

## Procedure:

Find a tree or woody plant that you can track for a year. I am a native of the Northeast, where we have all four seasons. Many of our trees are deciduous, meaning they lose their leaves in the late fall and don't start blooming again until spring. Most trees will develop flowers, but many are small and inconspicuous, so we don't realize that they flower. (Other trees develop cones.)

Trees often develop large quantities of fruits or seedpods. Two of my favorites are the horse chestnut tree and the linden tree. Both these trees have a cluster or grouping of flowers (called an inflorescence) arranged on a stem. If you choose a specimen like this, when depicting the flower at the height of its maturity, first draw an individual flower, and then tackle a whole stem of flowers.

A year in the life of a plant can be started anytime, including in the middle of winter. Identify a branch on your tree. Take a small cutting, make observations, and draw a section of a branch—any dormant buds (that will develop into the flowers and leaves in the spring) and perhaps a dried seedpod or fruit still attached to a stem. Sometimes some dried leaves are hanging on to the stems. Look down under the tree, and there may very well be leftover fruits or nuts from the tree. As spring comes, visit your tree frequently, getting a new branch and drawing the emerging buds and leaves. Make sure to draw some flowers, leaves, and later on the developing ovaries and finally the fruit or seed capsule.

Write down all kinds of observations you make. For example, how does your tree smell when it is flowering? In what order do parts of the tree develop? Who pollinates your tree's flowers? What kind of birds visit? As the leaves change color, create a drawing that features the fall colors.

By the end of the year you will have told the entire story of your tree's life and learned a lot about the botany of your tree. You will probably have a new appreciation of trees and their lifecycles.

*Horse Chestnut Tree (Aesculus hippocastanum), colored pencil on watercolor paper, 16 x 12 inches (40.6 x 30.5 cm). I did this commission of a horse chestnut tree for the Morven Museum and Garden, in Princeton, New Jersey. I started the drawing in the spring when the flowers emerged and continued drawing the developing fruit in the summer. I added the hardened "nut" in the fall.*

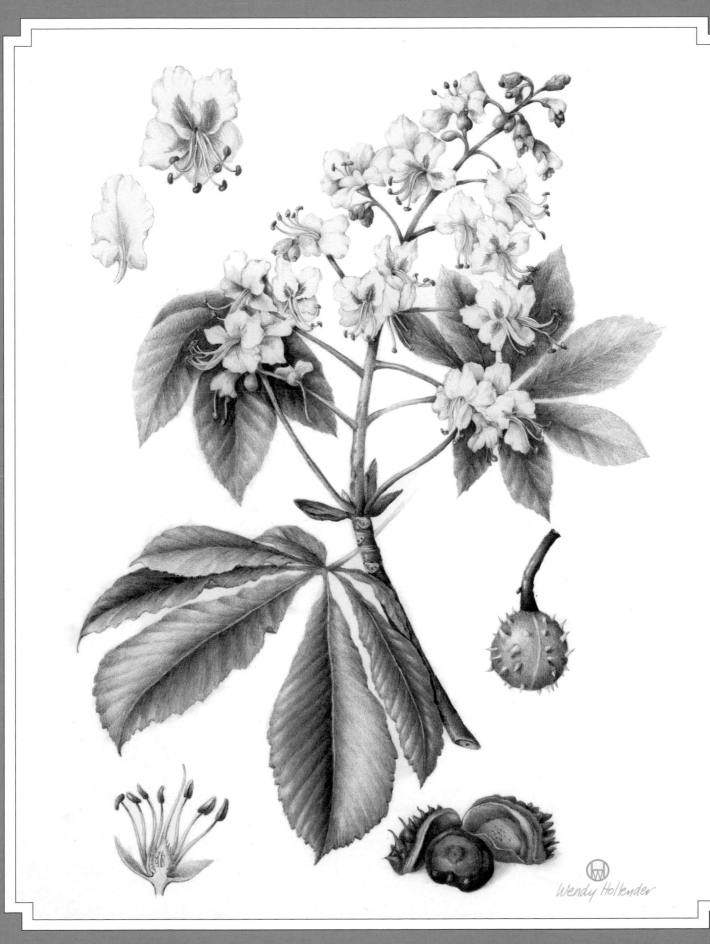

Wendy Hollender

# MAKING AN
# HERBARIUM PAGE

Now that you understand the function of a flower, it is time to study its structure. The best way to do this is to take it apart in a methodical way. Making an herbarium page will help you learn plant anatomy.

## PROCEDURE:

Carefully take apart one of your tulips, starting with the outer three petals and then continuing with the inner three petals. (Most tulips have six petals, but this can vary.) Actually, as mentioned on page 14, the petals on a tulip are technically tepals.

This process will expose the reproductive parts, all of which emanate from the center axis of the stem. You will find six stamens (male parts), each of which consists of an anther (top part) full of pollen and a filament (lower stalk); you will also find a pistil (female part) that consists of the stigma (which has three lobes) at the top and the ovary (which has three chambers) at the bottom.

At this point you may want to examine the reproductive parts of your tulip with your magnifying glass. (It is easier to see details once you have separated your parts.) In the exercise on pages 108 to 109, we will thoroughly discuss how to dissect an ovary for examination under a microscope or magnifying glass.

Arrange the parts on a plain piece of drawing paper. Label the parts and then either tape them down or leave them untaped. If you wish, include a whole flower and some leaves.

Cover the specimen with another piece of paper. Press it under some heavy books or use a press made for this purpose. (If you are pressing your specimen right in your sketchbook, it is a good idea to put a piece of photocopy paper over the specimen and then put the closed sketchbook under some heavy books.) Your herbarium page will be dry in approximately two weeks.

### WHAT YOU'LL NEED:

two tulips
drawing paper*
a single-edge razor blade
tape**
a magnifying glass

*You'll want to remove your drawing paper from your sketchbook, as the herbarium page will dry better this way.

**Archival tape is best, but I am not a purist and I use whatever I have. Though I would prefer my herbarium specimens to last a long time, it is most important to create them for use during the drawing process.

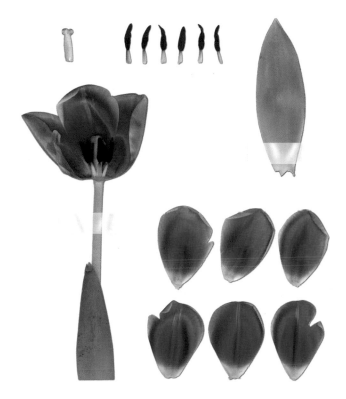

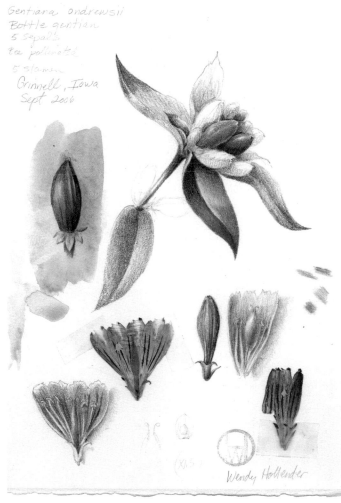

Gentiana andrewsii
Bottle gentian
5 sepals
Bee pollinate
5 stamen
Grinnell, Iowa
Sept 2006

Wendy Hollender

An herbarium page is a good reference tool, as it will exist long after your specimen would otherwise be available. Taking apart the flower and creating the page will also teach you a lot about the flower. Tulip parts (clockwise, from top left): one pistil, six stamens, one leaf, six petals, and one whole flower (with three tepals removed).

Often when I make herbarium pages I am out in the field and quickly take apart a flower and put it inside whatever notebook or sketchbook I have. I may even tape parts down right on my notebook pages along with my sketches and drawings.

# DRAWING THE REPRODUCTIVE PARTS OF A TULIP

Drawing the reproductive parts is a great way to learn the structure of a flower and practice your drawing skills at the same time.

## PROCEDURE:

As you recall, the tulip itself is a cup shape; however, the reproductive parts protected by the petals, when clustered together, are essentially a cone shape. For this exercise we will make four drawings, getting progressively closer to the individual reproductive parts of the tulip.

### WHAT YOU'LL NEED:

a tulip*

your tulip herbarium page (created during the exercise on pages 100 to 101)

a graphite pencil

drawing paper

an eraser

a single-edge razor blade

a ruler

a magnifying glass or a dissecting microscope

*If tulips are not available, any flower with large reproductive parts (such as lilies, magnolias, or daffodils) will work.

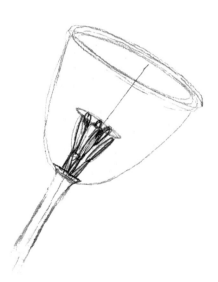

1

Draw the tulip, focusing on the reproductive parts as they appear clustered within the context of the entire flower. It is not necessary to depict the petals. Rather, you can articulate the basic cup shape with a simple outline. As discussed earlier, the reproductive parts of all flowers emanate from the center axis and stem of the flower.

2

Focus on the pattern formed by the seven reproductive parts, as they are attached to the stem. Try to capture the overall shape of the cluster as well as the positioning of the individual elements.

It is time to observe and draw the male and female parts separately. Refer to the herbarium page, and look at your parts under magnification. Begin with the stamens. Note the various shapes: The anther is slightly rounded (as it is likely full of pollen). The filament is essentially cylindrical. Draw the stamen both life size and enlarged.

In the very center of the tulip is the pistil. It has three sides and is shaped like a triangular cylinder. As you are drawing, carefully tone the pistil. Make sure also to render it from different angles, noting how it catches the light differently, depending on its position. Then, using your razor blade, horizontally dissect the pistil to expose the ovules and draw the horizontal section of your specimen. Look at it under magnification to clearly see the ovules.

— CREATING LONGITUDINAL DISSECTIONS —

Step 4 of this exercise features a horizontal section (also referred to as a cross-section). However, specimens can be dissected vertically as well. This is called a longitudinal dissection (or vertical section). If you were to vertically dissect the pistil of your specimen, you might see two rows of ovules, depending on where you dissect it. This view always reminds me of a vertical dissection of a cucumber.

Under magnification you may see the ovules of the tulip. They are sometimes hard to see, as they blend into the fleshy inside.

# The Joys of Drawing from Life

Whenever I find myself drawing on location, drawing in the field, it doesn't matter to me that past botanical illustrators and scientist have studied, documented, and photographed the plants that I am drawing. For me, it is as if I am on my own personal expedition, discovering nature's beauty for the first time.

Many artists like to keep on-location sketchbook journals. These usually consist of quick sketches of landscapes, people, and anything else of interest they encounter. My sketchbook pages are about plants, and they are very detailed. I try to capture the essence of the plant even if I don't plan on using the page for a more detailed drawing later on. The process of sitting quietly, studying the plant, and making the drawings is the goal in itself.

Drawing often initiates a process of discovery. For instance, when I was drawing the small flowers in the horse chestnut tree image on page 99 I noticed that some had yellow venation and others had pink venation. I wondered about this and started to read more about the plant. I discovered that the flowers start out yellow and turn pink after they are pollinated. That way the insects (in this case, bees) know to only go to the yellow flowers. Of course, I recorded this fascinating information in my sketchbook notes.

One of the joys of drawing with colored pencils is how easy it is to travel with and set up your materials. Traipsing through the jungle and setting up to work in front of a rare flower may sound exciting, but the reality is often less than ideal—and not conducive for detailed study and drawing. I do occasionally do it—particularly when I want to render a plant that is endangered or threatened (when it is not recommended to pick the flower), but often I find that it is more practical to use these excursions to record observations of the plant specimen or flower in my sketchbook and take some detailed photos. I can refer to these sketches later on, using them to render more detailed drawings in the comforts of another location, such as my studio.

When I am making sketchbook pages, I like to set myself up near where my plant is growing—at a table with a hard-backed chair so I can work comfortably. If the climate is hot and sunny or rainy, it is also extremely helpful to have some kind of protected roof, such as an umbrella. If I am lucky enough to have a cut specimen from the plant, I can comfortably draw it while at my table. I will refer to the plant growing as necessary, but I try and draw from a cut specimen. It is much easier to see details of structure when you can hold the plant in your hands and examine and draw it closely.

Many botanical gardens and preserves have restrictions on cutting flowers. I try whenever possible to introduce myself to appropriate staff and ask about the possibility of obtaining specimens. They are usually excited that I am interested in documenting their plants and often help me obtain samples as well as make suggestions on interesting plants to illustrate. I have met many a future client for my work this way.

During the process of sketching the flower, I gain an understanding of the local environment and the concerns and details about the plants growing there. While traveling, others might shop or go to museums; I like to get to know a place by drawing its plants.

*Blue Flag Iris (Iris versicolor)*, 2003, graphite and colored pencil on drawing paper, 12 x 9 inches (30.5 x 22.9 cm). *I created this sketchbook page while I was an artist in residence at the Edmund Niles Huyck Preserve in Rensselaerville, New York. To get a specimen I had to paddle a kayak across a pond. A few days later when I went back for another one, they were finished for the season, so I drove ten miles up the road to a slightly colder area and was able to get another flower to finish the drawing.*

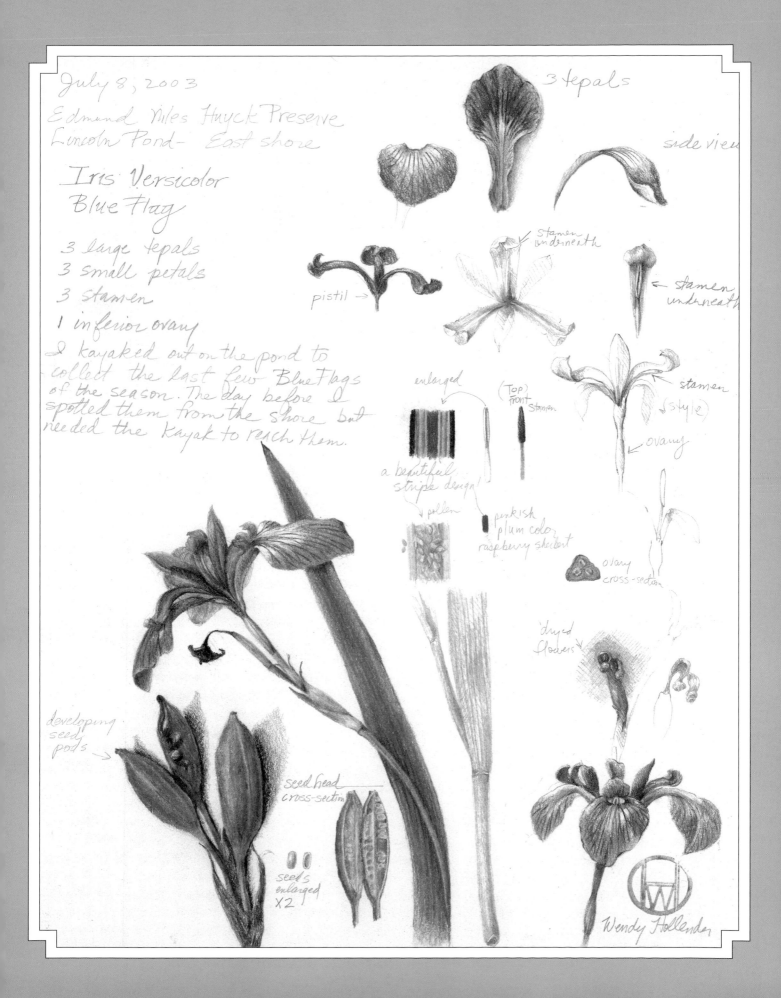

July 8, 2003
Edmund Niles Huyck Preserve
Lincoln Pond- East shore

Iris Versicolor
Blue Flag

3 large tepals
3 small petals
3 stamen
1 inferior ovary

I kayaked out on the pond to collect the last few Blue Flags of the season. The day before I spotted them from the shore but needed the kayak to reach them.

3 tepals

side view

stamen underneath

pistil →

stamen underneath

enlarged

(Top) Front stamen

stamen

(style)

ovary

a beautiful stripe design

pollen

pinkish plum color raspberry sherbert

ovary cross-section

dried flowers

developing seed pods →

seed head cross-section

seeds enlarged X2

Wendy Hollender

# MAKING A
# SKETCHBOOK PAGE

Creating sketchbook pages can be a lifelong pursuit. Think of it as a way to tell a plant's story with pictures and words. Every time you create and study a plant in this way, you will gain deeper understanding of the plant and put it in context with all the other plants you have studied. You will start to notice similarities in structure and perhaps understand why some plants are in the same family.

## PROCEDURE:

When working on location, make yourself comfortable and get to work right away. Many flowers picked in the wild have a short life span once they are cut. Leaves, stems, and fruits usually last longer. After procuring your specimen, put it in water immediately. Sometimes I put my flower in a plastic bag with a wet paper towel while I travel to a good working spot.

Observe the specimen, carefully making notes about what you see. Include the following information, if available: scientific name, common name, family name, where the specimen was collected, and the date. If you are lucky enough to have more than one flower, you could take one apart and create an herbarium page (as described on pages 100 to 101). Alternatively, you could carefully remove the reproductive parts—both to see them better and to dissect the ovary of your second flower (either vertically or laterally) and view the ovules.

Use your magnifying glass to view the parts of the flower that may not be visible to the naked eye. Then, carefully measure the relevant components of the specimen. Now you are ready to draw: Draw the stamen and pistil. Is the ovary superior or inferior? (A superior ovary is positioned above the point of attachment of the petals of a flower, such as a tulip. An inferior ovary is positioned below the petals, as is the case in an iris.) Make note of the amount of petals, stamen, and pistils.

Draw a petal. Count the petals and notice any details related to how they are attached to the stem.

Draw a leaf. Make note of the venation pattern. Is it paralleled veining or net veining? Sometimes making a quick rubbing on thin paper reveals the venation pattern and leaf margins for later study.

## WHAT YOU'LL NEED:

a graphite pencil

the basic twenty colored pencils

drawing paper or watercolor paper

an eraser

a ruler

tape

a single-edge razor blade

a magnifying glass

Ziploc bags or small jars*

*If you are using Ziploc bags, place several wet paper towels in each bag. If you are using small jars, fill them with water.

## NOTE:

This procedure should be done over and over again using different specimens. You can work from cut flowers, woody plants and tree branches that are flowering or fruiting, herbaceous plants, and so forth.

Examine the stem, and draw a segment of it. Now document the whole flower. First, draw quick thumbnail sketches of at least three views, simplifying the flower into basic geometric shapes. Do a front view, a side view, and a back view.

Next, make detailed line drawings of one or two of these views. Do thumbnail sketches that define the light source and the gradation you will try to achieve in more detail. Then shade each of the line drawings. Make color swatches with colored pencil, matching the colors in all parts of the flower, and label the pencils you used to mix the colors. If you have time, you can do some of your drawings in color

Your final page should be filled with observations and information, both beautiful and useful. These sketches can be turned into a finished composition later for a final drawing of the flower.

*Tulip (Tulipia), 2007, graphite and colored pencil on drawing paper, 12 x 9 inches (30.5 x 22.9 cm). This drawing shows the kind of information I like to include on my sketchbook pages. I used my color pencils only to make color notes, and I did the drawings in graphite. Including a root system, in this case a bulb, adds additional interest.*

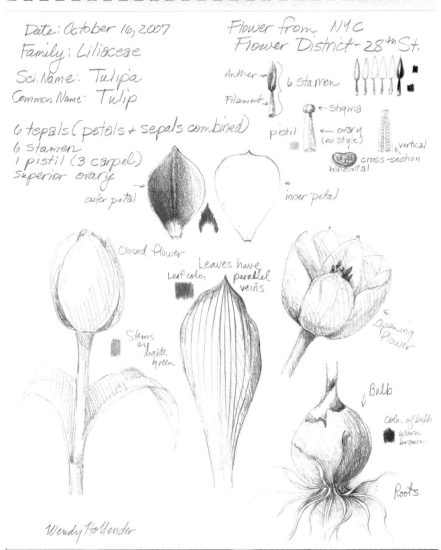

# Observing and Drawing Under Magnification

You have already learned some of the fundamentals of botany (including how to identify the reproductive parts of a flower and dissect an ovary). With this exercise we will take these skills to the next level. You will lean how to observe specimens under magnification, enlarge a specimen in a drawing, and note similarities and differences among various flowers. Studying plants under magnification opens up a new world. The closer you look, the more detail and form you can see and draw. In addition, structure seen under magnification will help you to add a three-dimensional quality to your drawings.

## Procedure:

Allow yourself plenty of time to enjoy this exercise. Carefully take apart the flower, as learned in the exercise about making an herbarium page (on pages 100 to 101).

Once the petals are off, remove one stamen from the receptacle and place it under the microscope or magnifying glass. Look at the anther and see if you can identify both the anther and the pollen. (Pollen has fine grains and often beautiful colors; it emerges from an open anther.)

To enlarge a specimen in your drawing, measure its height and width. If you want to enlarge it two times, for example, take each measurement and multiply it by two. If you want it three times larger, multiply each dimension by three. This way the height and width will stay in proportion.

Try to draw the anther enlarged about twice its actual size. Draw the anther life size as well. Draw a few different stamen views. Notice how the anther is connected to the filament, and draw each view carefully. Identify the ovary and draw it, again enlarged about twice its actual size. Draw it life size as well. Next, dissect it vertically. Observe the ovary under magnification and identify the ovules. (How can you miss them? They shine like pearls!) Draw the vertical section of your dissected ovary. Remember the light source of a sphere when toning each ovule.

Take an additional ovary and do a horizontal dissection. Observe under magnification and draw. Use your colored pencils to identify and draw the magnificent colors you see.

### WHAT YOU'LL NEED:

a flower with large reproductive parts*

a magnifying glass or a dissecting microscope

a single-edge razor blade

a graphite pencil

the basic twenty colored pencils

watercolor paper or drawing paper

an eraser

a ruler

*A tulip, daffodil, or lily would work well for this exercise.

### NOTE:

Dissect, observe, and draw other flowers. (For a real challenge, pick small flowers, such as the seaside goldenrod plant shown on page 112.) Next, observe and dissect fruits and look for similar formation of seed patterns. (Hint: A seed is a fertilized ovule.) Compare an ovary with a mature fruit from the same plant.

I never get bored when looking under the microscope. As I observe each part I like to imagine that I am a tiny insect crawling through my plant. Colors are vibrant, and repetitive patterns are visible. Each time I see what nature has created I experience a moment of a joy. Whenever I teach students how to use and look under a microscope, I notice that everyone—regardless of their age, gender, or background—reacts the same way. Everyone always smiles. It is amazing!

A dissected hibiscus ovary. The drawing on the left side shows the ovary still attached to the receptacle and the rest of the pistil. The middle picture is a horizontal section of the ovary showing the ovules and kind of looks like a tomato slice. The drawing on the right is a vertical section of the ovary showing the ovules in a different view.

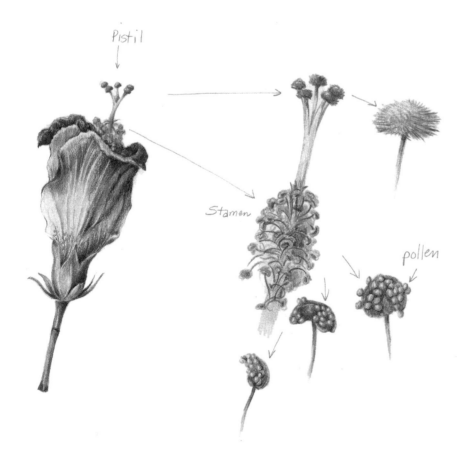

LEFT:
Hibiscus stamens and pistils are quite unusual. The stigmas resemble pom-poms that protrude from the flower like antennae.

# NATURE'S PATTERNS

Form and function go hand in hand in nature. As you study nature closely you will start to see the same patterns over and over again, including spirals (such as the pattern made by small flowers in the center of a sunflower or on the scales on an acorn cup or the spikes in the center of an echinacea), hexagons (seen on seed capsules of the sweetgum tree or fruit of a dogwood), and helixes (the three-dimensional spirals, such as on the tendrils of a vine).

All this, plus spectacular colors! Nature's arrangement of form and color is all for a reason, and the reason has more to do with efficiency than just looking pretty. Form serves to maximize usage of space (allowing as many seeds as possible to be tightly packed in to a small area), and color is used to attract pollinators. (Plants can't get up and walk around; they rely on other means to reproduce and travel.)

Spiral patterns are created at the apex of a plant's growth. Studying these patterns will help you draw them more accurately and easily. What at first might seem to be an overwhelming job becomes a simple unlocking of the underlying pattern. This pattern can first be copied as a simple outline, and then later details of form can be added.

One way to clearly see the patterns in nature is to take a photograph of a form (such as a pinecone, the center of a sunflower, or a pineapple). Place a piece of tracing paper over the photograph and draw the lines created by the individual scales, flowers, or sections of the form. Once you have started to pay attention to the patterns in nature, you will see them everywhere.

*Acorns (Quercus palustris), 2004, colored pencil on watercolor paper, 16 x 12 inches (40.6 x 30.5 cm). I studied this acorn branch under magnification and blew it up approximately six times for my final drawing.*

*London Plane Tree (Platanus x acerifolia) (detail), 2005, watercolor and colored pencils on watercolor paper, 16 x 12 inches (40.6 x 30.5 cm). I enlarged the pattern in the seed capsule of the London plane tree, focusing in on the pattern.*

*Sweet Gum Tree (Liquidambar styraciflua) Seed Capsule (detail), 2005, colored pencil on watercolor paper, 16 x 12 inches (40.6 x 30.5 cm). In this drawing I show the immature (green) seed capsule as well as the dried (brown) seed capsule.*

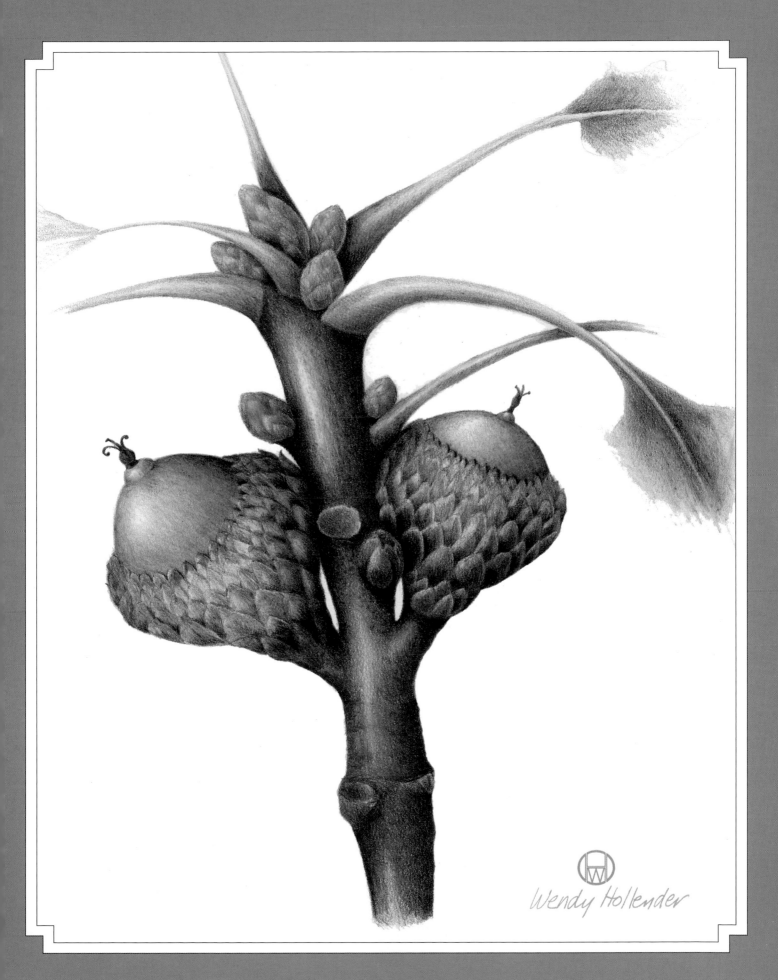

Wendy Hollender

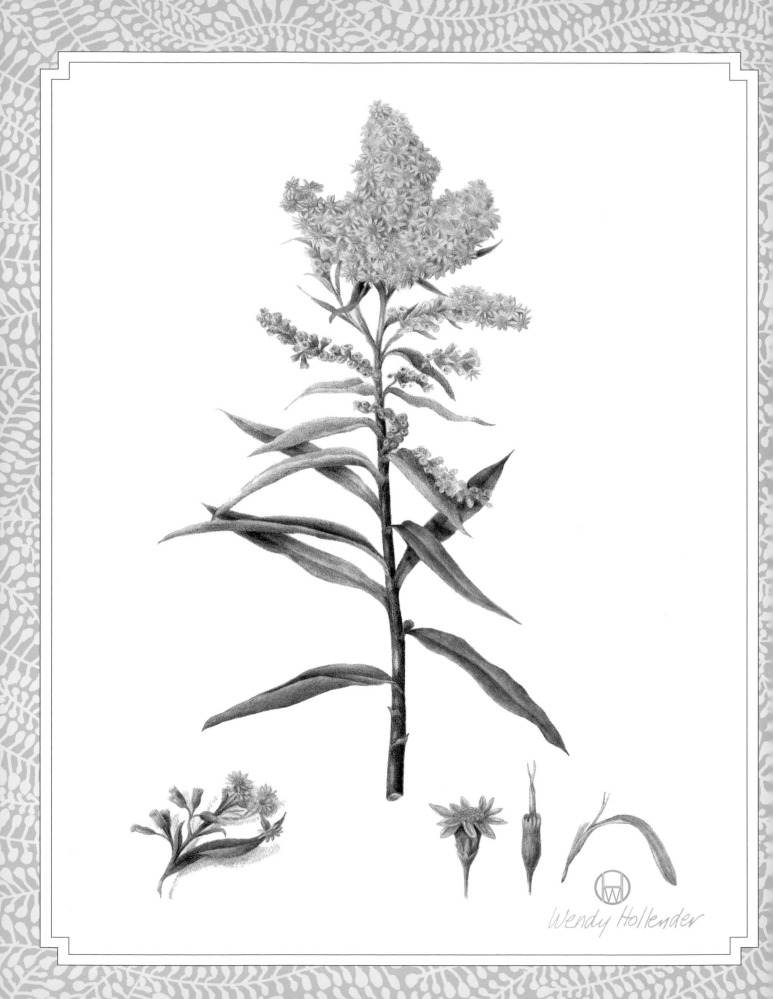

Wendy Hollender

# MASTERING ADVANCED DRAWING TECHNIQUES

*Seaside Goldenrod (Solidago sempervirens),*
2005, colored pencil on
watercolor paper, 16 x 12 inches
(40.6 x 30.5 cm). *This image shows a
single stem of a seaside goldenrod plant. The
tiny flowers appear to be a clump of gold, but
when studied closely under magnification
they look like miniature daisies. Notice at the
bottom of the drawing ( from left to right)
the enlarged group of flowers, the enlarged
inflorescent, the enlarged disc floret, and the
enlarged ray floret.*

Botanical drawing is a detail-oriented discipline that requires accurate rendering. The good news is that it does not require the artist to do a crime scene drawing! In other words, it is not crucial for you to document every petal or every variation of bending and twisting of your particular flower.

Once you understand the basic structure of the flower, you are free to take liberties. For instance, you, as the botanical artist, may want to delete information about this particular flower (for example, prune some leaves if they are covering too much of the stem) or even change it (for example, draw your leaves as they appeared in the wild, not wilted, as they appear on the specimen in your vase). As long as your final drawing correctly reflects the botanical elements of the species, making changes is not only acceptable but is often desirable.

An advanced drawing is a "finished" drawing, with all aspects of the flower or plant species represented. This chapter builds on all of the skills that you have learned in previous chapters. While I focus in depth on the nuances of creating an advanced drawing of a daisy, the concepts can be applied to the rendering of any other species you may want to draw.

# Drawing a Daisy in Black and White

This exercise concentrates on form, structure, perspective, overlapping elements, and toning with a single light source. These skills are the basis for all botanical drawing and painting. Regardless of the medium you use for your final illustration, you should have a solid grasp of these fundamental skills.

## Procedure:

Focus on and draw each of the main elements of the daisy, including a single petal, the whole flower head (from different angles), the stem, and the involucre; but first, let's take a moment to consider the botany of this amazing flower.

## The Botany

As a botanical artist, it is important to know basic information about the botany of each specimen that you render—in this exercise, the daisy. The daisy is a composite flower in the Asteraceae (sunflower) family. (Another flower in this family is the dahlia, which is presented as a drawing exercise in the next chapter.) We think of daisies as very simple flowers, but actually they are among the most complex flowers in existence.

A single daisy is actually made up of many tiny flowers and is thus botanically an inflorescence (a cluster or two or more flowers). The center of the daisy is a cluster of disk florets, each of which is a fertile flower containing stamens and a pistil. Each of the outer petals is an individual sterile flower comprising five fused petals held at their base. Inside the base of each of these outer petals is a tiny ray floret.

## A Single Petal

Take a moment to study your daisy under magnification. Look into the center of the daisy and observe all the tiny flowers. Next, look at the larger outer petals. Notice how each petal curls where it is attached to the center. Before you begin to draw, take your second daisy and carefully remove one of the petals. Look at the petal under magnification and observe how the base of the petal is actually a tiny tube shape and inside that is a ray floret.

Next, pay close attention to the tip of your petal, as sometimes it is notched. Look at the tip under magnification before you start to draw the petal. Avoid the desire to approximate and simplify such an important shape in a flower as its petal.

First, draw the petal life size. Then, enlarge the petal approximately twice its actual size and draw the petal again. As discussed earlier, to enlarge any botanical form, simply take its life-size measurement and enlarge it proportionally. For example, if the petal is 1¼ inch high by ⅜ inch wide and you want to make it twice as big, simply multiply everything by two. The enlarged petal will measure 2½ inches high by ¾ inch wide.

A petal that is drawn with an accurate contour is more interesting than an approximation of a petal.

## The Whole Flower Head

Once you have an understanding of one petal, it is easier to draw petals on the entire flower. When rendering a whole flower head, it is always a good idea to start with a view that will easily show the three-dimensional structure of the flower. A straight-on view is always the most challenging of the possible views to render, but since a daisy is a relatively flat flower, let's start with this view anyway.

I like to start with the center of the flower. This is where all of the growth and structural elements begin, so it is a natural place to begin your drawing. That way, your petals will appear to be attached to the entire flower—an extremely important step that beginners often neglect.

Take care in drawing each petal, showing it tapering as it goes into the center of the flower. If you draw your petals attached correctly, it will go a long way in making the drawing look natural and realistic.

Use the technique of "drawing through" introduced on pages 86 to 87. Even though the tapered end of the petal is

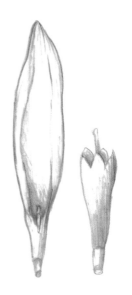

On the left is a petal. Inside the base is a tiny ray floret. The enlarged drawing on the right is the ray floret.

partially blocked behind the central disk, I continue my stroke as if the petal were going in to the center of the daisy. This helps me to render a tapering edge that otherwise might come out looking straight and stiff.

Once you have drawn in the petals—lightly at first and without a continuous, solid outline—you can focus on adding a bit of dimension to the center of the flower. Begin this by adding some toning to show the overlapping element of the petals. Next, add value to describe the light source on the form. By now I bet you realize how complex the daisy is!

When you understand the basic perspective of the circular, or straight-on, daisy, try drawing a more realistic and detailed daisy. Then, complete the next two views of the daisy by referring to your preliminary drawings of an ellipsis view and a cone-shaped view (from the exercises on pages 54 to 55).

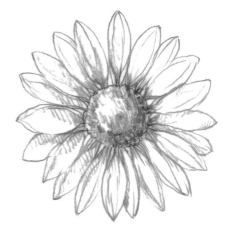

A straight-on view of a daisy. Notice how its outer contour fits into a circle.

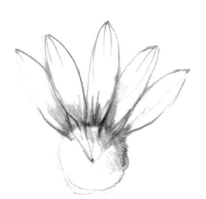

I created this rendering of the daisy petals using the draw-through technique. Notice how the petals appear to radiate out of the center axis of the daisy, like the spokes on a bicycle. The width of each petal tapers toward the center of the flower.

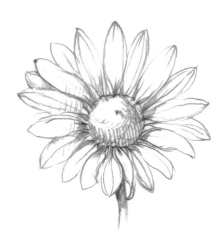

This view of the daisy features a mildly elliptical shape.

This drawing shows what can happen when the draw-through technique is not used. If you continue the imaginary sides of each petal in toward the center of the flower, you will notice that the petals do not radiate out of the center.

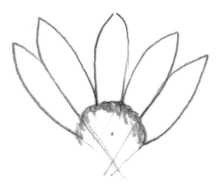

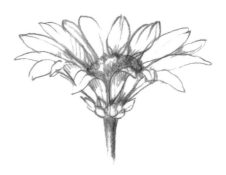

When the daisy is seen in profile, it has a cone shape. This view features both the inside and the underside of the flower.

## The Involucre

An involucre is a group or whorl of bracts that subtends the flower head in a composite flower. A bract is a leaflike structure at the base of a solitary flower, similar to a group of sepals (or an inflorescence, where they may resemble sepals and trick you into thinking the inflorescence is a single flower). A whorl is a ringlike arrangement of parts that radiate from a central point.

Use ellipses to help draw your involucre. You want to feel the roundness of this form and not imbue it with a straight edge. The central disk of the flower is like a round pincushion, and the involucre is like a cupped hand holding the cushion. I often feel that the reproductive parts of flowers are like pieces of exquisite jewelry. The central disk of the daisy certainly qualifies!

To get a better understanding of the involucre and central disk, take the flower that you have been deconstructing and carefully pull out the petals on one side. (Are you reminded of the little game "He loves me, he loves me not"?) This will reveal a clear view of the flower head and the involucre.

Take delight in all that you notice as you observe your stem and make notes. For example, as I drew the stem shown below I noticed little leaves attached at various junctures, often at the beginning of a new growth. I imagine there is a reason for this. Nature is very efficient, and most things have a reason. After you complete your drawing session, look up the answers to all of your questions and learn as you go.

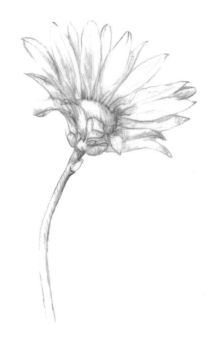

Here is the finished drawing of the angled daisy in profile.

This view (with the petals removed) shows the involucre, the structure that subtends the flower. When you render it, first draw a simple cup shape with the center disk inside.

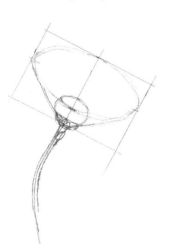

Here is a cone-shaped view of a daisy in profile. Notice the central axis is at an angle, as are the elliptical shapes.

## The Stem

Take a small grouping of daisies and lay them down flat on your paper. This is a good way to observe the stems and see their structure clearly. Stems are very important in a drawing. After all, they hold up the flower. Often they are drawn without much thought. Upon careful observation, however, you will see subtle changes in proportion and direction. (For instance, stems are rarely straight and the same thickness.) These subtleties will not only make your drawing much more accurate, but they will add to its overall beauty and grace.

In the daisy, the stem is a little thinner at the bottom and starts to widen slightly at the point where secondary stems, holding each daisy, appear. These secondary stems are quite a bit thinner than the larger stem that holds the whole inflorescence. Draw the center axis of each stem first, then add the width on either side. Make sure the stem is in the center of the flower. Stems are often cylindrical, so it is easy to tone them in relation to their light source, making them look exceptionally three-dimensional. I sometimes tone thin stems while holding a magnifying glass over my work to help me see better. Where the stem connects to the flower is a crucial area that demands your close attention. Usually they swell a little as they attach and hold up the elegant flower. A good rendering of the stems will help your flower stand tall and proud.

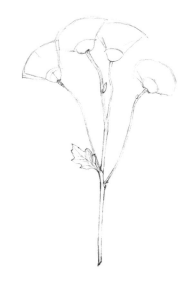

I first did a line drawing of my flowers—creating simple shapes on the stem to represent the focal point in the composition.

Then I drew each flower in detail.

---

### — CREATING —
### THUMBNAIL SKETCHES

Doing thumbnail sketches (or line drawings, such as the one above) allows you to plan several compositions quickly and increase your understanding of the elements that impact your final drawing. With practice you will learn to avoid certain views that make a composition problematic—such as views that are hard to draw (a straight-on view inside a flower), feature sharp angles (stems that overlap in a crisscross pattern), or that set up intersections (wilted or folded leaves).

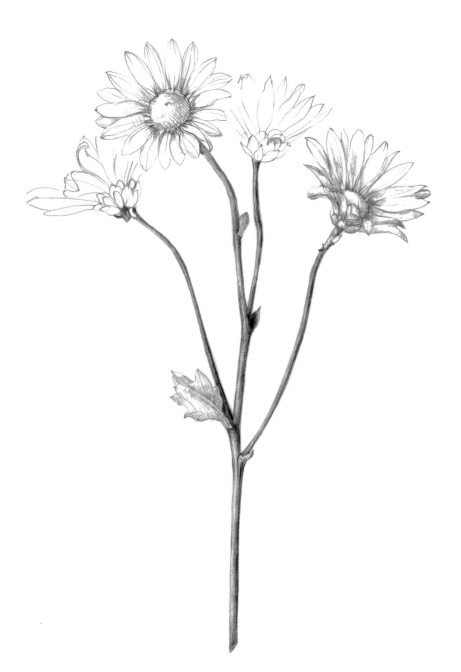

I began by drawing the stems. Then, instead of keeping the flowers as I had drawn them in my study of the stems, I decided to vary the views, referring to the drawings of the individual flowers that I did at the beginning of the process. This is an easy way to create or change a composition.

## — WHAT IS — IMPORTANT TO SHOW?

Any finished drawing should accurately represent the size and structure of the various components of your specimen. In addition, it should include:

- details of leaf venation and petals
- any overlapping forms
- any relevant patterns (for instance, in the case of the daisy, the spiral pattern in the central disk)

And finally, the drawing should address:

- how things are attached (and in what arrangements)
- how the light source articulates the basic form

Sometimes less is more. If you are going to add a minute detail, it must be accurate. A suggestion of a detail is often enough. You don't want your drawing to look stiff. Flowers are graceful; petals are delicate and have many subtleties that cannot be described with a heavy outline.

# DRAWING A DAISY IN COLOR

Once you have a line drawing with a bit of toning to show clearly the overlaps, you can start to add color to your drawing.

## PROCEDURE:

In the previous exercise, you focused on form, structure, overlapping elements, and toning. Now it is time to think about adding the color. As discussed on page 114, you can either work right on top of the final drawing from the previous exercise, or, if you are using Dura-Lar for this exercise, you can place this drafting film right on top of the final drawing from the previous exercise.

## The Colors

Before you start adding color to your drawing, first make color notes to approximate the local colors in the plant. This daisy has green stems, leaves, and bracts; the petals are white; and the central disk is yellow to yellowish green.

Even at this stage you should be thinking of both values and colors. Specifically, you are now choosing a range of values. (My specimen required dark to light green for the stems, leaves, and involucre; gray to white for the petals; and darker, greenish yellow to lighter, more pure yellow for the central disk.) The beauty of this technique is that all layers blend together, so that the sepia you put down in the first exercise will blend with the shadow areas on the drawing. Remember to choose your local color by holding your pencils right next to your flower. Choose pencils that are as close to the real color as possible, and blend two together if needed.

### WHAT YOU'LL NEED:

a bunch of daisies

a graphite pencil

the basic twenty colored pencils

Dura-Lar film (optional)*

an eraser

a ruler

your final black-and-white drawing from the previous exercise

*As discussed on page 114, you can do your final color drawing on either watercolor paper or Dura-Lar film.

### NOTE:

Once you complete this exercise, you will be ready to try drawing a similar flower, such as the orange dahlia shown on page 124.

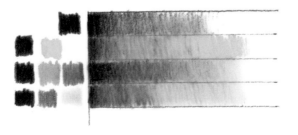

To render my specimen, I selected dark sepia #175, ivory #103, earth green yellowish #168, permanent green olive #167, cadmium yellow #107, and a cool gray 70% #7475 Verithin pencil. As in previous exercises, I made smoothie blends to simulate the colors I would try to capture in my final drawing.

## The Finished Drawing

If you were not aware before you started this exercise, then by now you certainly can appreciate just how complex of a flower this "simple daisy" is! How much detail can you show? When should details be almost microscopic? Now is the time to make a few executive decisions about what is important to show without sacrificing a natural-looking drawing. It also is a good time to assess your own abilities and consider what you are capable of showing well.

In making my drawing, I decided not to show all of the details in the center of the flower. Instead, I decided to do a separate, enlarged drawing of the disk florets. I felt confident that I could make my disks look three-dimensional, and so I tried to focus on that in this drawing. I knew that if the centers had dimension and I suggested overlapping of petals with some strong shadows, the flowers would look fine.

Once I had articulated this approach I was able to emphasize the area that would become the focal point of the composition. I usually complete this area first—and this drawing was no exception. Rendering white petals posed an additional challenge. By emphasizing the areas where the petals connect to the center with dark values, I could leave the rest of the petal fairly light, so it reads as white.

For this drawing, I worked on a transparent paper, called Dura-Lar, that is technically a drafting film. It takes colored pencil nicely, but I had to layer my pencils carefully because it saturates quicker than the hot-pressed watercolor paper. This surface has two advantages. First, because it is see-through I could place my preliminary drawings underneath it and draw right on top. Second, its transparency allowed me to work on both sides of the surface. So in this drawing I could emphasize the whiteness in my daisies by carefully painting the back side of the film with an opaque white paint such as gouache.

After I completed the main drawing, I decided on which other elements I wanted to add. In this case, I selected my drawing of the half-plucked daisy and drew that to show the roundness of the involucre and central disk. I also created an enlarged detail of a petal with a ray floret (twice its actual

size) and an enlarged disk floret (four times its actual size). And finally, I added a few falling petals to give movement to the composition.

As I always do, I began the process of adding color to my drawing by starting with the focal point—the central daisy.

## WHEN IS A DRAWING FINISHED?

How do you know when your drawing is finished? Students constantly ask me this question—often at a point when they are not sure what to do next. My answer is that usually when you are asking the question, you are about halfway there!

To evaluate how to proceed at this point, ask yourself the following questions. They will help you evaluate your overall composition and your rendering techniques.

- Have I clearly described what is in front and what is behind?
- Is the light source clear? Does it describe the three-dimensional form?
- Is there enough contrast? (Often colored pencil drawings are kind of fuzzy and lack contrast. Working further on a drawing, refining and crisping up edges, burnishing and polishing, and including a good range of values and contrast will give your drawing a sharper look, just like a sunny day appears!)
- Are my edges crisp and sharp?
- Is there too much outlining?
- Have I burnished and polished to intensify the color and to lose the texture of the paper (which may be distracting)?
- Are the petals on my flower clearly attached to the stem, and is my stem strong enough to hold up my flower?

After completing the color application, I turned over the Dura-Lar film and began to paint the back side with white gouache. For more extensive instructions on this technique, see pages 140 to 141.

*Daisy (Bellis perennis),* 2009, colored pencil on matte film, 12 x 9 inches (30.5 x 22.9 cm). *The process of drawing this daisy was quite complex, but in the end I wanted my drawing to simply feel light and airy, like a daisy.*

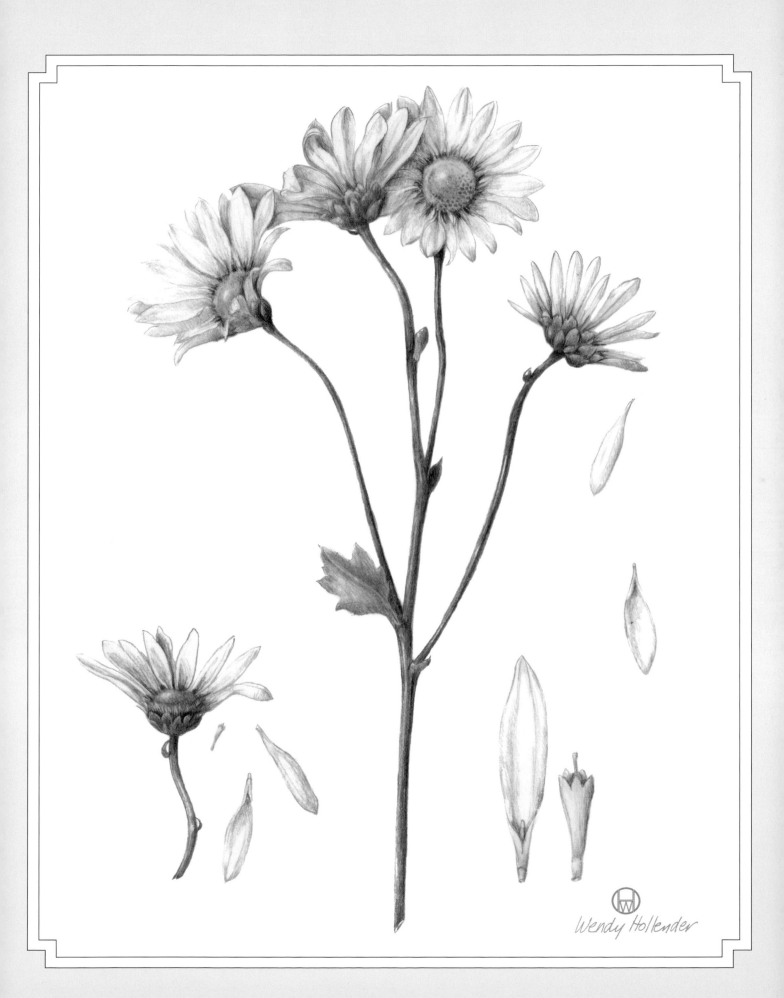

Wendy Hollender

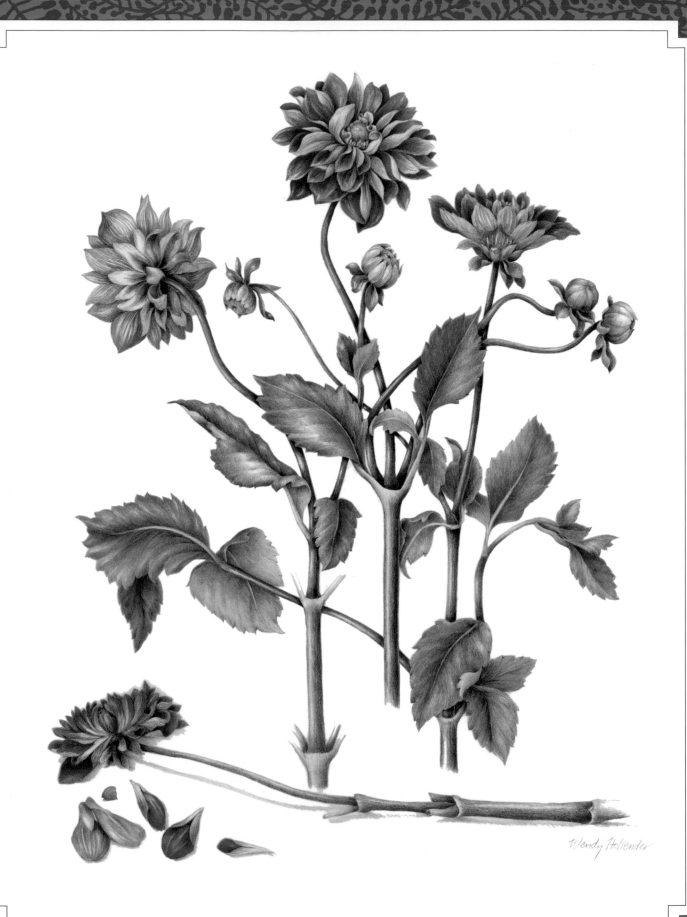

Wendy Hollender

# MASTERING ADVANCED COMPOSITIONS AND TECHNIQUES

*Orange Dahlia (Dahlia), 2009, colored pencil and gouache on matte film, 24 x 18 inches (61.0 x 45.7 cm). Like the daisy featured on page 123, the dahlia is also in the Asteraceae family. Can you see how the daisy and the dahlia are related? Notice similarities and differences.*

The traditional botanical illustration usually floats on a white background. When compared with other genres of art—such as still life, landscape, and portraiture—it hardly seems that composition is important for botanical illustration. But it is!

A good composition does not have to be complex; it just needs to get the job done. In other words, it needs to invite someone to look at your work and entice them to stay awhile. Too frequently compositions have sharp angles that point the viewer's eye away from the focal point or distracting elements that are visually overwhelming and annoying. When a composition is not pleasing, viewers simply turn away. When the composition is inviting, unusual, and interesting, viewers will want to look at the drawing over and over again.

When planning a composition, it is important to consider not only the placement of the various elements but also the combination and arrangement of colors. Planning your composition does not have to feel like a time-consuming chore, however. Simply take a few moments to consider your layout before jumping in and getting started on your drawing. Truly, this will save you from wishing you had done just that upon completion of the work.

# How to Plan a Composition

The word *compose* means to "put together." In the visual arts we refer to composition as the arrangement or placement of the elements in a drawing on the page. I like to take the mystery out of creating a composition by thinking of it as a developing adventure. In any event, the process should certainly not be intimidating.

There are lots of rules that govern composition, but anyone will tell you that great works of art often break these rules. Rather than describe these rules in detail, I would like to present the main goal of composition in a different way—as a method of highlighting the key elements in a drawing.

When planning a composition, ask yourself: What is going to be the main event? If it is a flower, or a grouping of flowers, make sure they are the focal point of the drawing. They should be located in an area without too many distracting elements vying for your attention.

Before you begin the drawing, measure the flowers and make sure they will fit on the paper and not run off the page. Leave room for the stems and leaves, which are the supporting cast (and not the stars of the drawing), and perhaps position them in a less-than-central location. Avoid sharp, intersecting angles, as they are distracting.

You can plan a composition in two ways. The first approach is called additive. This means you start your drawing and then add elements as needed to fill out the composition. I call the second approach "calculated composition." In this method you plan your entire composition ahead of time on separate pieces of tracing paper; you then assemble the elements and carefully redraw the final image on a new piece of paper.

I prefer the first method. I like to draw directly on my good paper and build my compositions as I go. If I am working on a transparent surface, such as a sheet of Dura-Lar film, I do some preliminary drawings that I can put together by placing the film sheet over the drawings. Planning a composition in this additive way feels like I am going on an exploratory walk, taking turns as I see something interesting without knowing my final destination. This is not to say I don't think about my composition ahead of time. I just like to leave my options open.

---

## — EVALUATING A COMPOSITION —

When you think you are finished with a drawing, leave it overnight and take a fresh look the next day. Prop your drawing up so you get a vertical orientation when you look at it. Step back and look at a distance, and then look more closely. It is easier to see what needs to be done when you have a bit of distance from your work. Sometimes you get a pleasant surprise. I have felt on many occasions that mice came in the middle of the night and finished my drawing for me. To evaluate your composition, ask these questions:

- Is there a clear focal point in the drawing? Is it where you want the viewer to focus, such as on a central flower or somewhere else?
- Are there any annoying sharp angles and lines that direct the viewer and confuse the composition?
- Is the space balanced?

*Torch Ginger (Etlingera elatior)*, 2007, watercolor and colored pencil on watercolor paper, 30 x 20 inches (76.2 x 50.8 cm) *I completed this image of a torch ginger, but then I learned about an important botanical characteristic and decided I needed to make some changes to the flower. In addition, I found the background to be distracting. (The strong diagonal horizon line led the viewer's eye off the page; I decided that removing it would create a better composition.)*

*Torch Ginger (detail)*. The fertile flowers are distinguished by their yellow rings.

*Torch Ginger (Etlingera elatior)*, 2009, watercolor and colored pencil on watercolor paper, 30 x 20 inches (76.2 x 50.8 cm). *I added a row of fertile flowers to the main flower as well as a hummingbird, who is fertilizing the flowers. I also made the background much more subtle. The final image was more accurate, botanically speaking, and had a stronger composition.*

# Drawing a Dahlia in Full Bloom

If you are fortunate enough to find a dahlia or other specimen of exceptional beauty at its peak flowering, I urge you to try your hand at rendering it. The illustrations of my work and its step-by-step progress can serve as guidelines, but you should use this exercise as an opportunity to create your own original composition and feel your way through the creative process.

## Procedure:

The dahlia that is the subject of my drawing was growing at the Brooklyn Botanic Garden in the fall of 2008. Only one flower on the plant was in bloom, and it was spectacular. The horticulture staff in the garden generously allowed me to cut the specimen at its peak.

As is often the case, drawing this large and complex flower was a race against time. To capture the blossom at its peak, I needed to plan the steps of my drawing carefully so I could complete the image before the flower wilted and died.

Using drawing paper and a graphite pencil, I immediately drew the large, composite flower because I knew it would not last very long. The flower was more than 5 inches in diameter, and to show it in a composition with leaves and stems required a large piece of paper. At the time I only had 8½ x 11-inch paper with me. Since I don't like to draw such a complex flower and then have to redraw it on bigger paper, I decided I would work on Dura-Lar film for the final drawing. Having made this decision right away, I was able to relax and take the time to render a detailed drawing of the main flower.

As I was certain that this flower would be the focal point of my composition, and I wanted to capture how the petals overlapped one another, I paid particular attention to the center of the flower and how the petals got progressively larger as they radiated out from this point. Creating the overlapping areas of petals was challenging and required a lot of patience. It was crucial to show the form of each petal and the variations of concave surface contours. I did this by careful toning the petals in the center. Once I gained an understanding of how to draw these petals, I did not tone the whole flower.

After drawing the main flower, I planned my overall composition in a thumbnail sketch at the lower left, so I had a sense of how I would add in the stems and leaves. (Later on I went back to the Brooklyn Botanic Garden and made the small drawings of the bud and partially open flower to add in my final piece.)

Elma Elizabeth
BBG

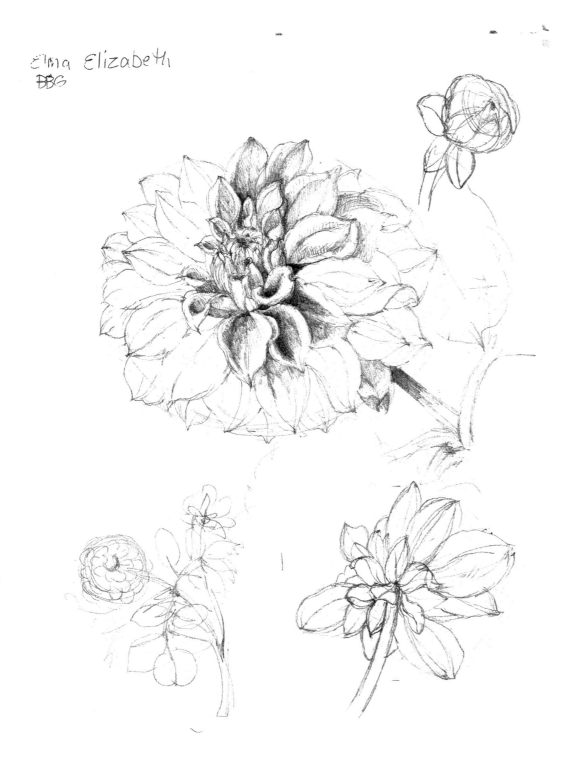

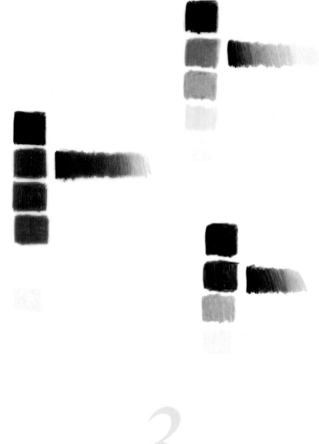

I selected the colors I would use to render the flower, leaves, and stem, as follows:

**Flowers:** red violet #194, purple violet #136, and middle purple pink #125

**Leaves:** permanent green olive #167, earth green yellowish #168, and cadmium yellow lemon #205

**Stems:** burnt sienna #283 and earth green yellowish #168

In addition, I selected dark sepia #175 for toning and ivory #103 for burnishing.

I laid out small squares of each colored pencil and practiced smooth toning bars to capture the colors in the plant. Creating a good range of dark to light values was very important for this drawing—both to convey the complex petals and to create contrast between the overlapping areas.

Back in my studio, on a sheet of large drawing paper, I continued to develop the composition—sketching in the locations of most of the leaves and drawing in detail the ones closest to the blooming flower. I used ellipses as guides for the perspective of the blooming flower, the partially open flower, and the bud.

I drew the leaves and connecting stem junctures closest to my flower very carefully, as I wanted to capture the characteristics of how they were attached and the graceful way they grew on the plant. I only lightly sketched the other leaves, as I needed to get on to the final drawing while my flower was (thankfully) still alive.

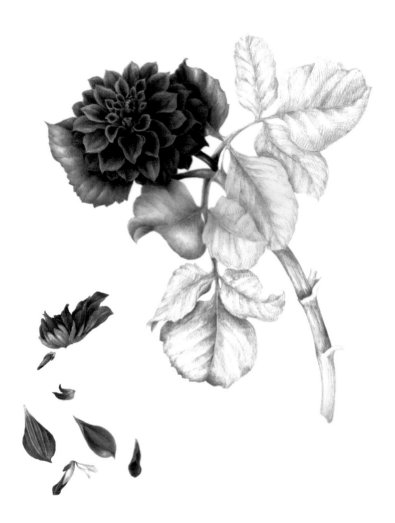

At this stage I got out a large sheet of Dura-Lar film, measuring 24 x 18 inches. Placing the Dura-Lar film on top of my compositional drawing, I started to render the main elements in dark sepia #175. Adding value and color at the same time, I completed the color drawing of the main flower right away because at this point the real flower was on its way out. (I took lots of photographs, just in case; however, a photograph would not be able to capture the exact overlapping of petals and accurate colors I would need to complete a realistic drawing.)

Next, I drew the leaves and stems nestled behind the flower. Notice that even in the areas without color the drawing clearly shows the details of the leaves and stems, capturing the three-dimensional quality of the plant. To achieve this I rendered exactly with my dark sepia #175 pencil. Then I added the color on top, being especially careful to use a full range of values.

While my flower was still alive, and before I completely rendered the color on the leaves and stems, I decided to pull apart my main flower and look closely at the petals and the individual flower parts on the dahlia. I wanted to fill out the composition, so I tossed some of these elements on the bottom left of my drawing. I liked this idea, so I drew them in. Sometimes I draw enlargements of dissections in a composition, but for this piece I wanted more grace and less of a scientific approach. I let the dahlia speak to me and help in planning the final piece.

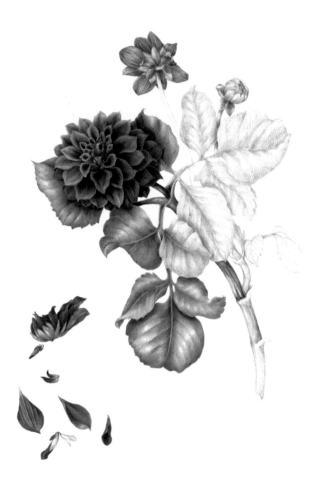

Because this drawing was on Dura-Lar film (which is transparent), on the back side of my drawing I was able to add more dark details and render areas to enhance parts of the drawing. I also applied white opaque paint very carefully on top of the major elements in the composition to bring them in the foreground and create the illusion of other elements becoming part of the background.

After having added in the elements to the bottom left, I wanted to pull the composition up and to the right, for better overall balance. I did this by adding in the smaller, partially opened flower and the bud. It is important to note that these flowers were not in the original plant. I went back to the garden, studied similar dahlias, and created this composition based on what could be possible, not what was actually growing on my particular plant at that particular time. As I rendered the stems and leaves in color, I focused on the overlapping elements.

*Dahlia (Dahlia 'Elma Elizabeth'), 2009,*
*colored pencil and gouache on matte film,*
*24 x 18 inches (61.0 x 45.7 cm).*
*This large dahlia was so heavy it*
*gave the stem a lovely graceful bend that became*
*an important compositional element.*

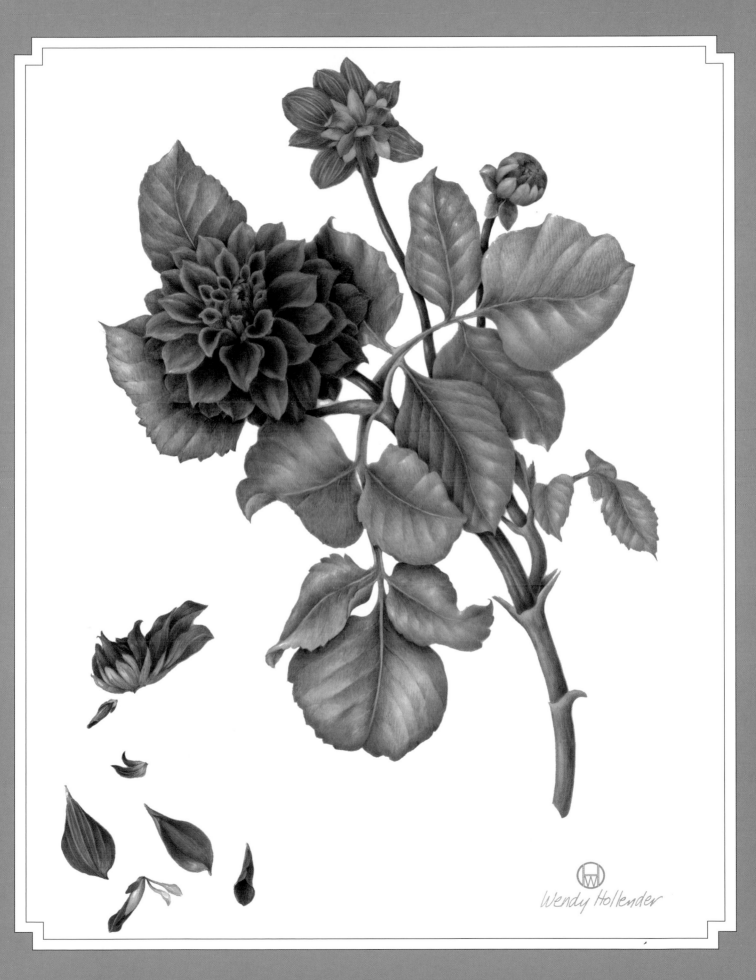

Wendy Hollender

# USING WATERCOLOR PENCILS

Watercolor pencils can evoke the feeling of watercolor and also speed up the layering process, which can be helpful for large areas of a drawing. Learning to use them effectively can also add a brightness and intensity to your colors.

## PROCEDURE:

Set up your leaf in an appealing manner, concentrating on forming a gentle, arching loop. Use tape to hold down the leaf to a piece of paper, if necessary. Adjust your light source so that it comes from the upper left. Then follow the steps below.

### WHAT YOU'LL NEED:

a tulip leaf

a permanent green olive #167 watercolor pencil

a permanent green olive #167 pencil

an earth green yellowish #168 pencil

a chrome oxide green #278 pencil (optional)

a dark sepia #175 pencil

an ivory #103 pencil

a cool gray 70% #747.5 Verithin pencil

a black #747 Verithin pencil

photocopy paper

tape

watercolor paper

a waterbrush

an eraser

a ruler

a gooseneck lamp

*1* Using your watercolor pencils, practice drawing both flat color and then gradated color. The color bars below show what happens to watercolor pencils (from left to right): consistent application of color; consistent color, smoothed with a waterbrush; graduated application of values; and graduated application of values, smoothed with a waterbrush.

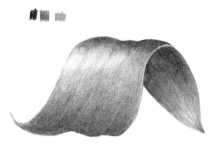

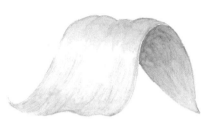

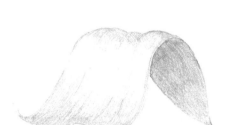

Now you are ready to start rendering a twisted leaf, with its subtle highlights and shadows. Use a green Albrecht Dürer watercolor pencil just like a regular ("dry," Polychromos) colored pencil for the first layer. Remember the surface contour of the ribbon you created on pages 86 to 87 when rendering this leaf. Be careful to apply a minimal amount of color in the areas that will remain light, as it is easier to retain a light-to-dark wash when less pigment is applied during this initial layer.

With a watercolor paintbrush, carefully wet your pencil drawing as you would when painting with regular watercolors. You will immediately notice that the pigment turns to watercolor. Working from light to dark facilitates the light-to-dark transition that is characteristic of watercolor, as the paintbrush picks up more pigment as it goes. For highlights, allow the bare paper to show, and do not paint it with pigment. Keep the watercolor wet as you work, otherwise unwanted lines and edges will appear. Work a small area at a time.

Once you have completed the watercolor area, allow it to dry fully and then switch to your Polychromos colored pencils. Continue rendering the form until you have reached saturation.

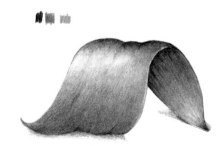

Using your Verithin cool gray 70% #747.5 and Verithin black #747 pencils, add in a shadow underneath the leaf to enhance the depth in your drawing.

# DEPICTING WHITE FLOWERS

When the local color of a flower is light in value, such as a white lily or a yellow daffodil, how do you get enough contrast? Do you still use dark values? This exercise helps to answer these questions.

## PROCEDURE:

Set up your specimen in a pleasing manner and then follow the steps below.

### WHAT YOU'LL NEED:

a white flower*

a graphite pencil

a permanent green olive #167 watercolor pencil

a dark sepia #175 watercolor pencil

the basic twenty colored pencils

watercolor paper

an eraser

a ruler

waterbrush

*A white lily would work well for this exercise, as would a white rose or a white tulip.

Practice blending your colors, using both your watercolor pencils and your colored pencils. In the image to the left, I blended dark sepia #175 (with both colored pencil and watercolor pencil), permanent green olive #167 (again with both mediums), and then (with only colored pencil) Venetian red #190 and dark cadmium orange #115 for the stamen and red violet #194 and purple violet #136 for the pistil of the lily.

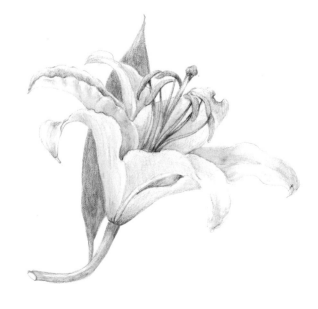

Now you are ready to begin rendering your specimen. Using your graphite pencil, lightly draw the outline of the flower. Next, using your dark sepia #175 watercolor pencil, put a light layer of values on the flower. Then, using your permanent green olive #175 watercolor pencil, put a light layer of color on the leaf and stem. Using your colored pencils, lightly articulate the details on the reproductive parts of your flower.

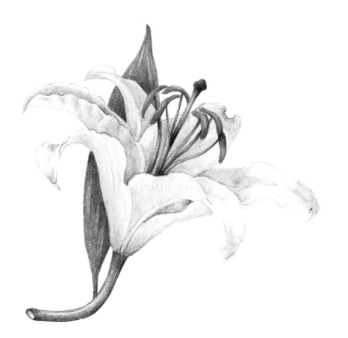

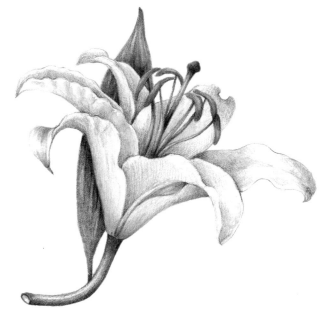

Using your waterbrush, wet the leaves. Clean the brush and then wet the flower. And finally, enhance the color in the reproductive parts. Notice that even though I haven't touched the white petals since the first layer of watercolor, by working on the leaves and details of the reproductive parts, the flower looks more complete. Ask yourself why that is.

Using your Verithin dark brown #746 and black #747 pencils, tone and emphasize the edges of the petals. I added a touch of cadmium yellow lemon #205 for the center vein on the front petal and a little more detail on the leaf and stem. Add the finishing touches to your drawing. Remember that the success of rendering a white flower is to get very dark in select areas but to use less of each dark value and more of each lighter value; also make sure that your paper shows through for the highlights.

## DEPICTING LIGHT-COLORED FORMS

Both light- and dark-colored forms use a complete range of values, from light to dark. Light-colored forms simply use proportionally less of each dark value and proportionally more of each light value. Study the value triangles to the right, paying particular attention to the difference in the ratio of each value relative to the others in both the light- and dark-colored forms. (Note: Mid-tone forms, which are not represented in the art on the right, contain an equal ratio of light and dark values.)

Lighter forms use more lighter values and fewer darker values (left). On darker forms, the ratio is reversed (right). However, both light- and dark-colored forms contain all nine values.

# DRAWING COMPLEX FLOWER CENTERS AND DETAILS

The reproductive parts in the centers of flowers are complex and are often left to the end in a drawing. I prefer taking the opposite approach. After I have drawn the outline of my flower with a complex center I draw the details on the center first and then add the details on the petals behind the center next. This ensures that all the petals are attached to the center of the flower.

## PROCEDURE:

Once you have chosen a flower with a visible and complex center set up a view where you can see the reproductive parts clearly. Look very closely at this center, using any form of magnification that you have. Understanding the basic structures of the stamen and the pistil will help you draw these features accurately.

### WHAT YOU'LL NEED:

a camellia*

a graphite pencil

the basic twenty colored pencils

watercolor paper

an eraser

a ruler

*If you do not have access to a camellia, then you could use a rose or an anemone. Essentially, you want a flower with lots of stamen.

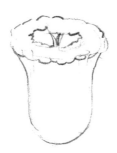

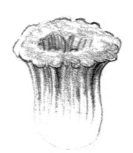

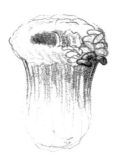

Using your graphite pencil, draw the outline of the reproductive parts of your specimen. In the case of the camellia, it is a cup shape formed by fused stamen. Even when you cannot see the individual stems of stamens, you can convey their quality by using strong lines that follow their contours.

Noting your light source, tone the overall form of your specimen. Also, begin adding color. (At this point, I started to add some of the yellow of the anthers on top. To do this, I shaded in the general direction that the filaments made rather than worrying about shading each individual stamen.)

Look at the reproductive parts closely under magnification. Add the detail shapes of the anthers and filaments to enhance the three-dimensional look. A Verithin pencil is good for these minute details because it has a sharper, harder point than a regular pencil.

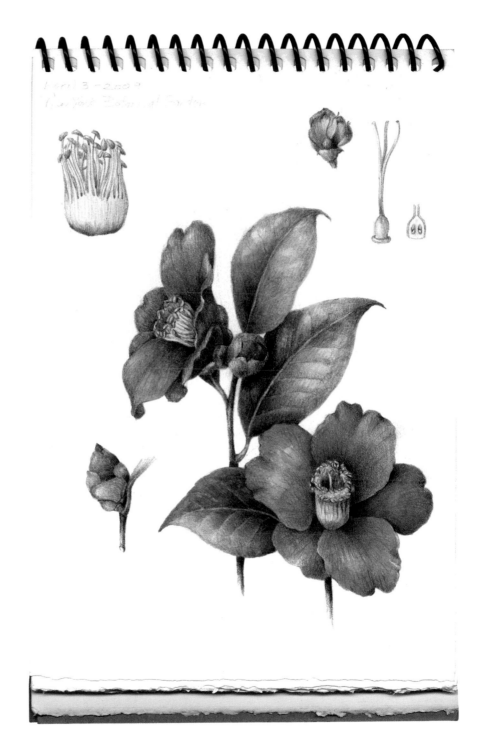

Add in the final colors. Keep layering your colors to saturation, making sure there is good contrast to convey the message that the anthers are overlapping in a whorl and that the filaments are bunched below.

*Camellia (Camellia japonica), 2009, colored pencil on watercolor paper, 11 x 8½ inches (27.9 x 21.6 cm). In this sketchbook page I've shown two views of the camellia—a bud and, of course, details of the reproductive parts.*

# ALTERNATIVE BACKGROUNDS

Botanical illustration is traditionally rendered on a white or an off-white background. For variety, I sometimes like to tint my paper with watercolor and create a warm-toned surface on which I can work. I also like to make my paper look old and distressed. I avoid working on colored paper, because I prefer to retain the brightness of colors when working on a white background, and if I want a toned background I like variations in the surface.

Occasionally I include a semi-landscape background in my drawings, putting my plant in its natural habitat. I create this background with light washes of watercolor. Backgrounds really change the look of your drawing and also have an effect on the edges of your detailed botanical elements. For this reason I highly recommend putting in your background first, or at least before you've done the extensive rendering and details. Otherwise, you may not be pleased with what happens to the drawing.

Using liquid frisket will allow you to put in a background but retain white areas for a light or white flower. To employ this technique, simply paint the areas that you want to remain white with frisket, and then paint your paper with watercolor. The areas with frisket will resist the watercolor. Once your background has dried you can remove the frisket and render those areas to completion. (Note: Always apply your colored pencil after you have removed the frisket. If you apply colored pencil and then frisket, the colored pencil will rub off when you remove the frisket.)

I also like working on Dura-Lar, which I used in drawing the dahlia on page 133. On this surface I can render the front with colored pencils. Then I can turn the film over, and with an opaque white paint such as gouache I can carefully paint over my botanical elements. I then mount the drawing on a darker piece of paper or work on the back with colored pencils to create texture and value.

Pierre-Joseph Redouté, *Still life with Roses and Anemone*, 1832, watercolor on vellum, 12$^1$2 x 9$^1$4 inches (31.8 x 23.5 cm) *Even Pierre-Joseph Redouté used a colored background occasionally in his work. I believe he used gouache paint for this purpose, as gouache is opaque rather than transparent.*

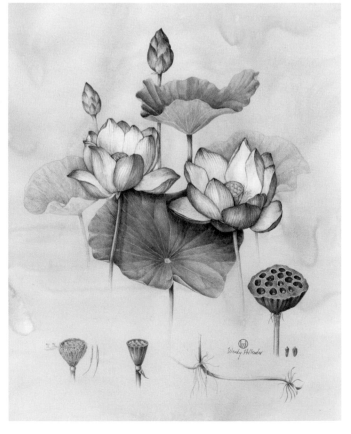

*Sacred Lotus (Nelumbo nucifera), 2007, watercolor and colored pencil on watercolor paper, 30 x 20 inches (76.2 x 50.8 cm) For this image I utilized the frisket technique to render the background with a watercolor wash. This is a slow process, and one that allows a fair amount of control.*

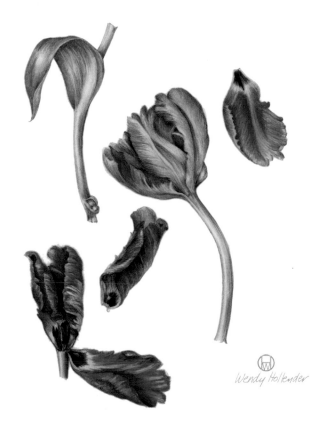

Wendy Hollender

## THE ADVANTAGES OF WORKING ON DURA-LAR FILM

Drawing on Dura-Lar film is an alternative to working on hot-pressed watercolor paper. It works well with colored pencils and allows you to take several shortcuts, including:

- 🍃 You can see through this surface, so you can draw on paper first.
- 🍃 Color saturates more quickly on Dura-Lar than it does on watercolor paper, but be careful—you still need to maintain a good range of values.
- 🍃 When you are finished with the image on the front, you can turn the film over and work on the reverse side.
- 🍃 You can cover all or part of your composition with an opaque white paint such as gouache to bring elements into the front.
- 🍃 You can mount your drawing on a darker paper to change the background color.

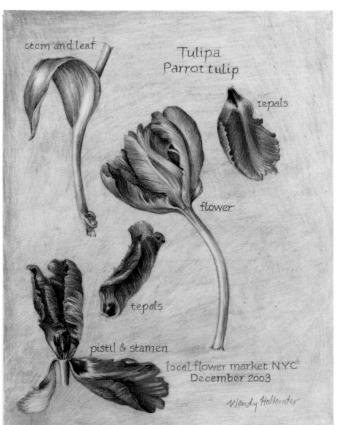

TOP:
In this drawing on Dura-Lar film, I first rendered the flowers in color, working on a white background. Then I turned the film over and painted some elements with white opaque paint on the back side to make them more vibrant.

LEFT:
*Parrot Tulip (Tulipa)*, 2009, colored pencil and gouache on matte film, 11 x 8½ inches (27.9 x 21.6 cm). *Even though Dura-Lar film is transparent, it is possible to create an opaque background, as I did here with colored pencils.*

# Afterword

I have thought a lot about the discipline of botanical drawing—how it relates to the broader picture of the world in which we live today, and particularly how it pertains to our need to create more sustainable life practices in the future.

It would be wonderful to see us reverse the trend that is leading to the endangerment of flora and fauna. Studying and drawing plants has cultivated in me a personal wish to live more in harmony with nature. This desire became so strong that after living for thirty-five years in Manhattan I recently decided to buy and move to a farm in Ulster County, New York (two hours northwest of New York City). I can now grow my own plants, watch their lifecycle develop, and draw (and eat) what I grow.

As botanical artists, we have an opportunity to put the plants—and their importance in our lives in all their functions—into the foreground. A deeper understanding of plant life can only enhance and educate our world.

People often ask me, Why not just take a photograph? And how is botanical illustration different from flower painting? My answer comes from the experience of studying a plant slowly and methodically, which is what a botanical illustrator is required to do. A flower painter looks at the whole and approximates the feeling in color, often including vases, a still-life setup, or an outdoor landscape in the painting. The photographer can only capture a plant as it is. By contrast, the botanical artist can choose what to include (or not include) in a composition. More to the point than some of these technical distinctions, however, is that upon completing a plant drawing or study, the botanical artist has a deep understanding of a particular specimen—one that cannot be adequately expressed in words but that hopefully is evident in the finished illustration.

On page 97 there is a sketchbook page of a century plant that I drew at the St. George Botanical Garden in St. Croix. The director of the garden pointed it out to me and said it was rare, endangered, and had never been drawn. The flowers were twenty feet up, at the end of a long stalk. I said, if you can get me a flowering branch, I will draw it. He had a gardener immediately cut one down. When I showed the individual flowers to the botanist (who had been director of this particular garden for more than ten years) he exclaimed, "I had no idea that the flowers looked like this!" As a botanical artist, we can bring into focus the details of plants that are otherwise not obvious. We can highlight details of which even a botanist may not be aware.

The lack of appreciation for nature is usually not done with conscious intent, but more often because of the fast pace at which we live. We are just so busy, and pulled in so many directions, that there is hardly time to slow down and appreciate a plant or flower up close. One of the most important aspects of drawing is that it takes time. You have to give yourself over to the process, slow down to understand and see a botanical subject in all its glory.

I hope my book has given you time to slow down and experience nature in all its detail and to appreciate the wonder of the natural world. I encourage you to use your botanical skills to make the world more appreciative of plants and their importance on our planet.

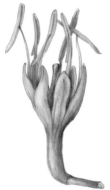

Detail of the century plant shown on page 97

# Sources

## Art Supplies

Purchasing art supplies online is a convenient way to find materials that are not stocked by your local art store. You can often save money as well. Here are a few online retailers that carry difficult-to-find art materials:

AMAZON.COM carries the battery-operated KP-4A Panasonic pencil sharpener.

DICKBLICK.COM sells individual Faber-Castell Polychromos pencils.

WHARTDESIGN.COM has custom-made spiral sketchbooks with hot-pressed watercolor paper.

## Classes and Institutions

Here are a few organizations with which you can pursue additional studies in botanical art and illustration and view botanical art:

ARTPLANTAE (www.artplantae.com) is an excellent online resource for botanical books, current botanical events, and botanical programs.

The BROOKLYN BOTANIC GARDEN (www.bbg.org) offers classes in botanical art, houses a large floreligium collection, and has regular botanical exhibitions.

FILOLI (www.filoli) has a program in botanical art and illustration in a breathtaking setting.

The HUNT INSTITUTE FOR BOTANICAL DOCUMENTATION (http://huntbot.andrew.cmu.edu) houses a large collection of botanical art and exhibits newly acquired work every three years. To be accepted into its collection is a benchmark accomplishment. It is part of Carnegie Mellon University.

KEW GARDENS (www.kew.org) houses the newly built Shirley Sherwood Gallery of Botanical Art as well as the unusual and amazing gallery of the botanical work of Marianne North.

The MISSOURI BOTANICAL GARDEN LIBRARY (www.illustratedgarden.org/mobot/rarebooks) has a digital collection of high-resolution antique botanical prints available for use online.

The NEW YORK BOTANICAL GARDEN (www.nybg. org) has the most comprehensive botanical art and illustration program in the world and an extensive botanical art and rare book collection.

## Botanical Networking

Another way to take yourself to the next level is to explore the world of professional artists. Here are a few of the organizations that you might consider joining and with which you can exhibit:

The AMERICAN SOCIETY OF BOTANICAL ARTISTS (ASBA) (http://huntbot.andrew.cmu.edu/ASBA) sponsors international juried exhibitions, publishes an informative magazine, and hosts wonderful yearly conferences. There are local chapters.

The GUILD OF NATURAL SCIENCE ILLUSTRATORS (www.gnsi.org) provides an excellent handbook of scientific illustration and hosts an annual conference.

The COLORED PENCIL SOCIETY (www.cpsa.org) has local chapters, conferences, and online galleries. It is also a good source for research on colored pencil techniques.

# INDEX